RYTON, CRAWCROOK & GREENSIDE

THROUGH TIME

John Boothroyd
with Nick Neave

AMBERLEY PUBLISHING

First published 2012

Amberley Publishing
The Hill, Stroud
Gloucestershire, GL5 4EP

www.amberley-books.com

Copyright © John Boothroyd with Nick Neave, 2012

The right of John Boothroyd with Nick Neave to
be identified as the Authors of this work has been
asserted in accordance with the Copyrights, Designs
and Patents Act 1988.

ISBN 978 1 4456 0710 8

British Library Cataloguing in Publication Data.
A catalogue record for this book is available from
the British Library.

Typeset in 9.5pt on 12pt Celeste.
Typesetting by Amberley Publishing.
Printed in the UK.

Acknowledgements

This book is the result of collaboration between members and friends of two Local History Groups and a co-ordinating author.

Chapters 1, 2, and 3 are mostly the work of members of Ryton Local History Society. Text was written by John Boothroyd with invaluable local knowledge, suggestions, proofreading and support provided by Mick Hardy, John Carrick, Dr Tom Yellowley and particularly Graeme Charlton. Many historic photographs were provided by Gateshead Libraries. These were added to and selections made by John Boothroyd, Graeme Charlton and Dr Tom Yellowley. Mick Gibson assisted with restoration work. 'New' photographs were provided by John Boothroyd.

Chapter 4 is mostly the work of members of Greenside Local History Group: Audrey Pyle, John Bell (photography), David Hesketh (text), Maureen Blacklock and John Murray, supported and encouraged by many other members.

Nick Neave, author of similar books on Gateshead and Whickham, advised where necessary and provided links with the publishers.

Copyright ownership of the photographs is as follows: Copyright for the modern photographs in Chapters 1-3 resides with John Boothroyd (although these may be freely used for non-profit purposes with acknowledgement). Copyright for the modern photographs in Chapter 4 resides with John Bell, and with John Boothroyd (for page 77) and Dawn Foster (for page 85). Copyright for the old photographs resides with Dr Tom Yellowley for pages 44, 67 and 73, Tommy Elliott for page 76, Betty Spark for page 84, Doreen Davison for page 86, Peter Phazey for page 88, Carole Jacobson for page 90 and Terry Kelly for page 94.

Gateshead Libraries kindly supplied the old photographs on pages 6, 8, 14, 20, 25, 27, 30, 33, 39, 41, 42, 47, 54, 55, 56, 61, 62, 63, 64, 69, 79, 83, 91 and 96.

Newcastle Libraries kindly supplied the 'old' photograph on the front cover.

Members of the Local History Groups of Ryton and Greenside, Mick Hardy, John Carrick and particularly Malcolm Anderson kindly supplied the 'old' photographs on pages: 7, 9, 10 11,12, 13, 15, 16, 17, 18, 19, 21, 22, 24, 26, 28, 29, 31,32, 34, 35, 36, 37, 38, 40, 43, 45, 46, 48, 49, 50, 52, 53, 57, 58, 59, 60, 65, 66, 68, 70, 71, 72, 74, 75, 77, 78, 80, 81, 82, 85, 87, 89, 92, 93 and 95.

Many people over the years have provided information that has since been used in this book. Many others have provided encouragement whilst it was being compiled.

Thank you to all those who have contributed in any way.

Introduction

This book has been put together to help you the reader get a sense of how and why our district has changed since the first photographs were taken in Victorian times. Younger residents and those new to the area usually have little idea of how great these changes have been or what shaped the way their communities look now. A modern view of an older picture is a really powerful way of speaking to both the older and the newer resident, and this is the format used for this book.

Ryton, Crawcrook and Greenside are three linked communities in the far north-west corner of the old County Durham. They are linked because for generations they shared the same parish, the same Coal Company and the same Urban District Council. This part of the old County Durham (now Gateshead, Tyne and Wear) has a gently rolling landscape and is largely rural. Throughout its history its economic lifeblood has been the coal trade, a situation that came to an abrupt end in the 1960s when all five of the local collieries closed for the last time.

At the centre of these communities was Ryton, centre of the parish and centre of administration. The original village contains an impressive display of historic buildings and is attractively situated above wooded slopes and a riverside. This rural idyll was ideal commuting country for well-heeled Tynesiders, and with the coming of the railways in the mid-1800s Ryton developed a sizeable housing stock and population that were very different from the colliery communities that surrounded it.

The coal trade in Ryton is very old. In the 1600s and 1700s the riverside parishes of Ryton, Whickham and Gateshead were the main suppliers of London's coal, being close to the river for transport and having coal seams near the surface that did not require sophisticated technology to mine. Coal mining continued to prosper and remained viable through to the 1960s. Outside the old commuter belt, it shaped the location, size, layout and architecture of the communities we know today.

In the modern era, new road networks and housing estates have been added and employment can be found on a few local industrial estates. But the world has changed and the area is mostly dormitory accommodation for a mobile workforce working anywhere and everywhere in the region.

The book has been written (and photographed) partly for the challenge of an interesting project, but mostly to help local people enjoy their neighbourhood and make some sense of what they see. This has been important to members of the Local History Groups. It is a main reason why such groups exist, but it is also a while since any up-to-date book has been available for purchase on these three districts. So, we hope you find it useful, but more importantly we hope you enjoy what you find.

John Boothroyd

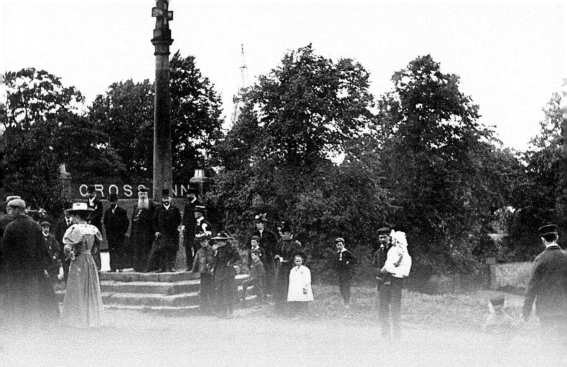

CHAPTER 1

Around Old Ryton and The Willows

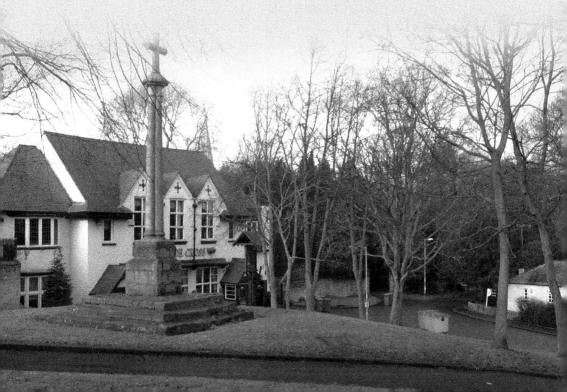

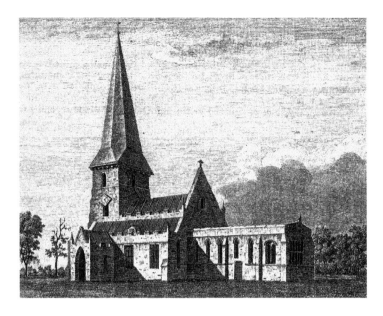

Church of the Holy Cross

Built about the year 1220, Ryton's oldest church once served a parish stretching as far as Blaydon, Rowlands Gill and Chopwell. Its appearance has changed little over the centuries, although this early print shows the chancel roof before it was redesigned in 1877. Within the leafy churchyard lies a tumulus, probably both a burial mound and fort at different periods of time. This is a site of great strategic importance as it overlooks the first point upstream where the old River Tyne could be forded on the road between Scotland and the south. It is the reason why old Ryton was founded here. What better place to start our journey through time?

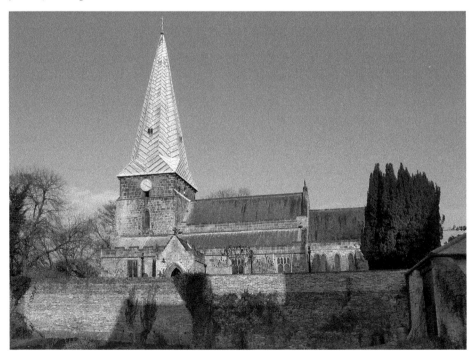

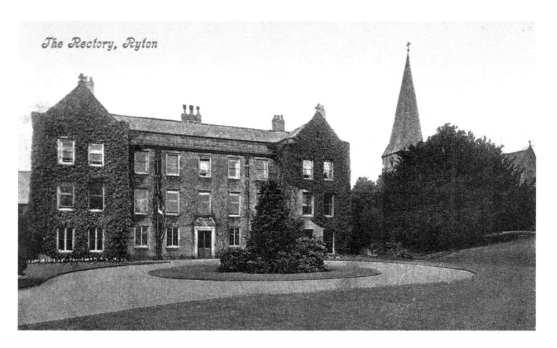

The Rectory, Ryton

A Grand Rectory

Ryton's prosperity was built on the coal trade and the Prince Bishops of Durham held local mining rights. When Prince Bishop Lord Crewe had the rectories at both Ryton and neighbouring Whickham rebuilt, these parishes were at the height of their importance as national coal resources. Lord Crewe's shows of grandeur ruffled a few feathers at Queen Anne's court and those that succeeded him had to make do with the lesser title of 'Bishop'. He did leave his mark though: '1709' and his coat of arms still adorn the rectory doorway. The property is now subdivided into two private residences.

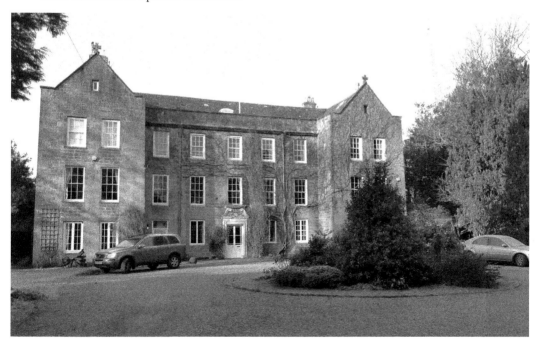

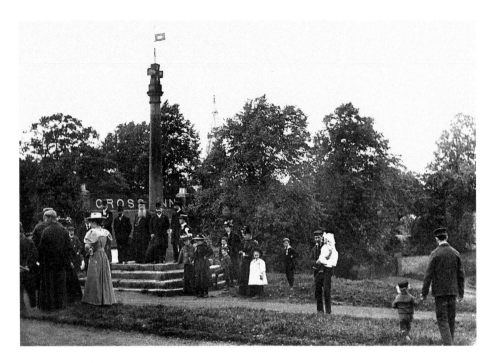

Meet You at the Ryton Cross

The Village Cross at Ryton has long been a traditional meeting point for people of the area. It seems best-known as the location for the 'hirings', the twice-yearly gathering of agricultural workers and servants where individuals were hired for service and the occasion used for a celebratory fair and general party. In the 1860s the hirings were banished to the Willows after getting out of hand and thirty years later wound up altogether. But you can't keep a popular idea down forever and there have been several recent revivals as 'community events'. The occasion here is thought to be a gathering of local temperance supporters.

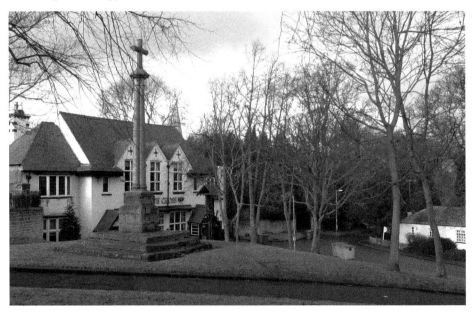

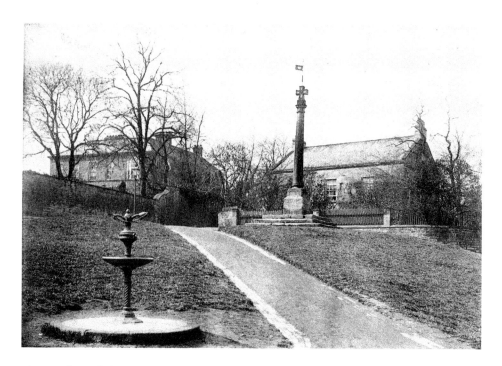

The Lambs and the Cross

This photograph is interesting in that it shows not only a picture of the rather fine fountain, but also the location of Ryton House. Both Cross House and Ryton House were owned at one time by the Lamb family, prominent local coal and landowners, after whom Lamb's Dene and the Lamb's Arms public house in Crawcrook are named. Cross House has survived to become the modern Community Centre, but Ryton House had more difficulties in adapting to the twentieth century. It existed for a time as the Conservative Club, with market gardening in the grounds, but in the 1950s it was bought by a speculative builder, demolished and the Ryton 'Hall' Drive estate was built on the site.

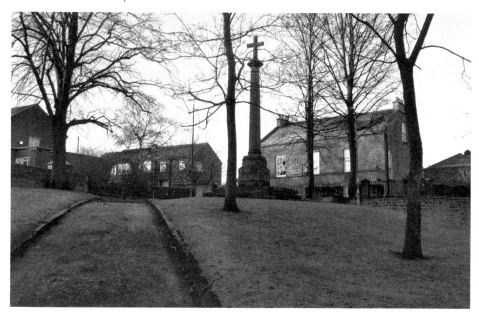

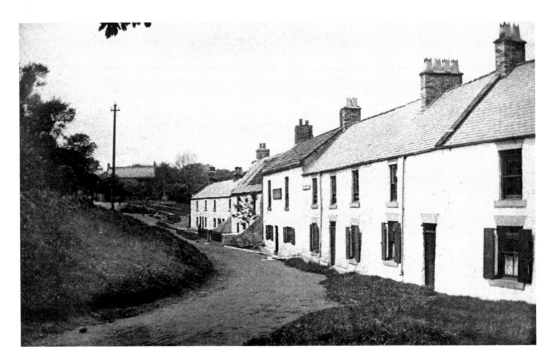

Three Jolly Fellow Post Office Lads

The original Three Jolly Fellows Inn was located in a front-room parlour halfway along this row of whitewashed buildings. The rear of the same building later acted as a post office. The cottages on either side remained standing for half a century after the inn was rebuilt in the 1890s. Those on the near side were known as Elvaston Cottages, those on the far side as Cowen's Cottages and part of Cross Terrace. The new inn was known as the Jolly Fellows, an end to the series of name changes that included the Three Jolly Fellows, the Three Jolly Lads and even for a time the Post Office Inn!

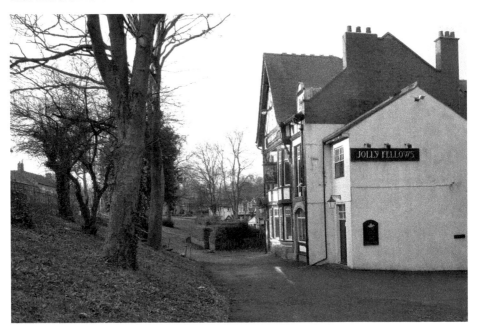

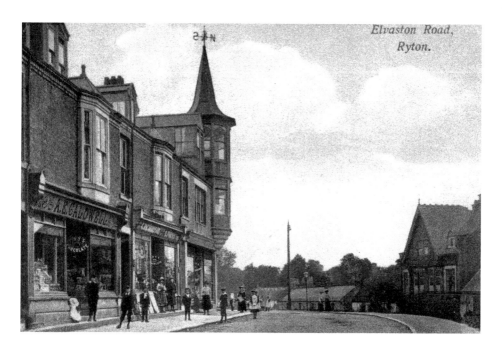

Elvaston Road, Ryton.

Room With a View

This iconic image shows a Ryton Village with a full array of local shops, of which only the chemist's survives. The chemist's serves the medical practice now housed in the former bank premises next door. This was originally Lambton's Bank later taken over by Lloyds: one of a number of businesses that moved away from the village to the newer shopping centre at Lane Head. The terrace is Edwardian and replaced an estate boundary wall with stables on the other side. The Elvaston Hall estate was occupied for a time by Charles Parsons, inventor of the steam turbine, and took in lands east of what was to become Northumberland Road.

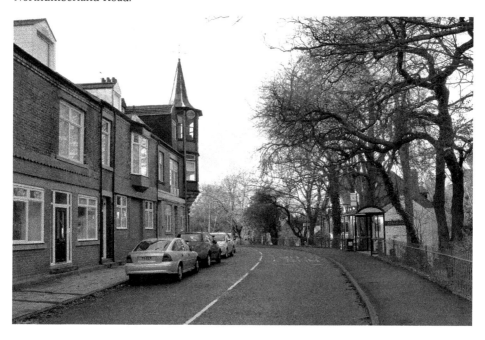

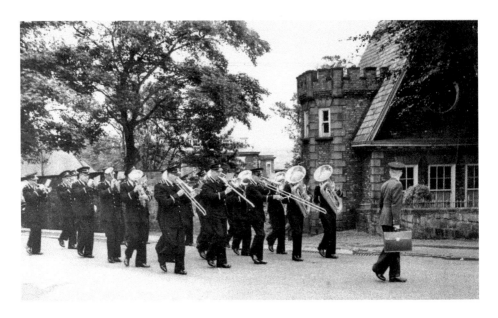

A Grand Tune for a Grand House

The Salvation Army Band is helping celebrate the centenary of Ryton Urban District Council (1963). The wonderfully shaped Lodge protects the entrance to Ryton Grove, a grand Georgian house built for Newcastle merchant William Boyd. This was one of the first in the area to be built as a country retreat, a trend which accelerated in the later Victorian period when the railway made rural Ryton even easier to reach from Newcastle. Originally facing the river and with lands that stretched almost as far, it was later the property of Thomas Spencer, owner of the Newburn Steelworks. In more recent memory it belonged to the Church Army. It is now once more a private residence.

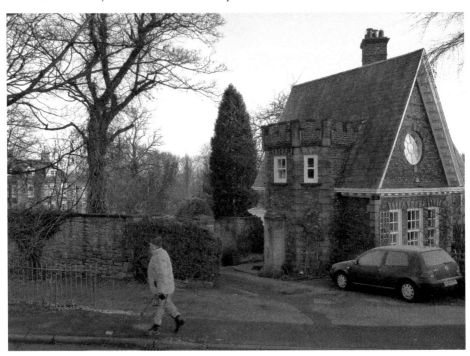

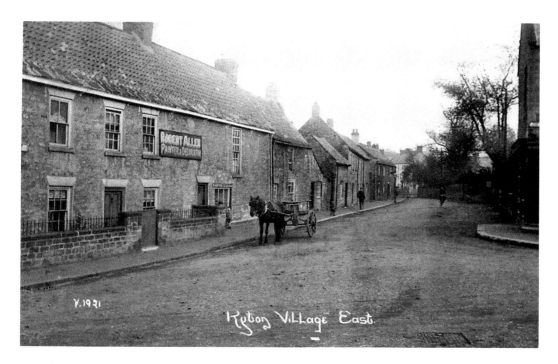

'Town Street' or 'Village East'

This row of dwellings stretched from the Grove Lodge to the Half Moon Inn and was part of what was formerly known as Town Street. Behind it stood the old Grove Farm. Interestingly, you can still see where doors and windows were located, as the lowest six-foot of the houses has been re-used as garden walling for the newer properties behind. The architecture of the Half Moon remains in the traditional Northumbrian style. This was also the style of the nearest competitors (the Cross Inn, Jolly Fellows and Ryton Hotel), all of which were given an Edwardian-style makeover and rebuilt and whose earlier forms can be seen elsewhere in this book.

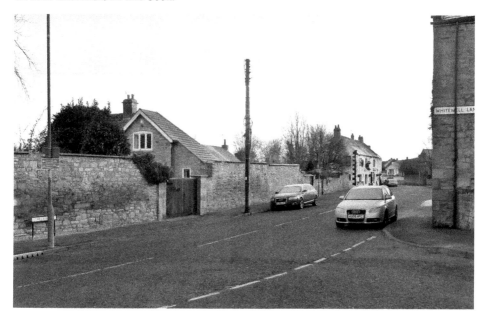

Hall to Club to Office to Flat

The Lawn was another of the Lamb family residences alongside Ryton House and Cross House. The central portion is the original main house; the eastern part a later addition. The heyday of grand houses such as these came to an end in the period leading up to the First World War and most struggled to remain viable. Many were taken over by clubs. Ryton Social Club moved from Cross House to the Lawn before their current home was opened in 1964. For a while afterwards office accommodation was provided, before the main buildings were converted into flats and the adjoining land used to build new properties.

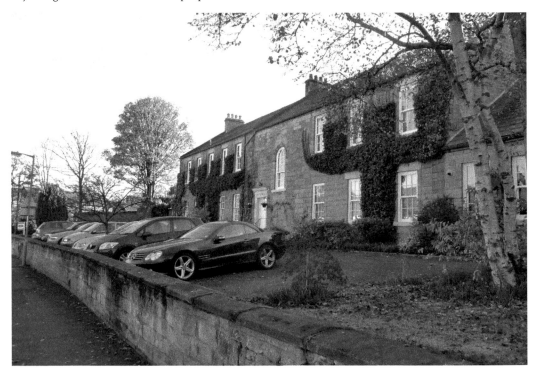

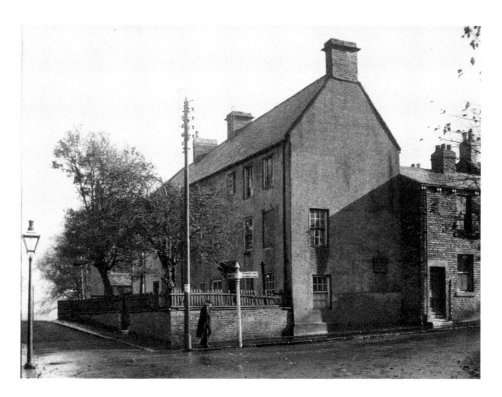

Barracks to Bungalows

These buildings were known as 'Spencer's buildings' and those beyond as 'the Barracks'. The latter is thought to refer to when militia uniforms and arms were stored there during the wars against Napoleonic France. In their later years they were divided into tenements and were some of the poorest housing in the district. They were replaced by the older persons' bungalows built in the 1960s by Ryton Urban District Council. The track east from the village is called Peth Lane, a traditional route to the river crossing points but now no more than a footpath.

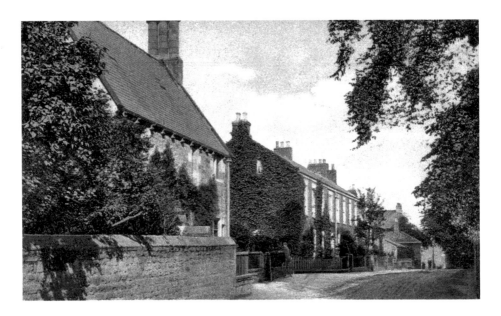

Charles Thorp's Dene Head

On the left is Dene Head House, a delightfully eccentric residence built for the Archdeacon Charles Thorp as his proposed retirement home and now divided into three separate dwellings. In its grounds was a small school built in the late 1700s and the predecessor to the school in Barmoor. The archdeacon was Rector of Ryton from 1807 to 1863 and had responsibility for buildings in the Durham Diocese. As an early recycler, he incorporated into his new house windows and door framings from the demolished Durham Market House (as well as chimneys from the rectory!) Beyond Dene Head House are two red-brick Georgian houses built in the same period as Ryton Grove and Ryton House, whose boundary walls are to the right. The stone-built houses beyond these seem best-known as the site of the first Methodist licensed preaching room in Ryton, in what is now Pinfold Cottage.

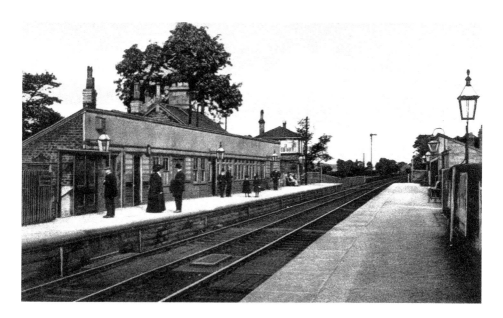

A Station No More

When the link between Ryton Station and Newcastle opened in 1839, the character of the village started to change forever. In particular, two groups of individuals made their mark. Those seeking pleasure and leisure found a quaint country village and a pretty riverside day-tripping spot, as well as a suitable location for curling, golfing and rugby. Commuters found a place in the country that they could easily reach from the city. Next to the station, members of Newcastle Curling Club made use of the ponds that had developed between the railway embankment and the north-facing slopes by creating rinks in brick and concrete that may still be traced in the undergrowth. The station was closed in 1954.

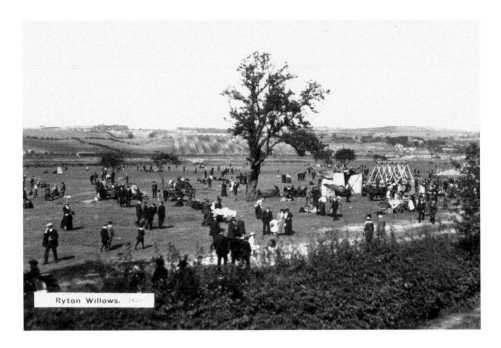

Ryton Willows.

A Walk on The Willows

The character of The Willows changed in the first years of the twentieth century, when the Tyne Improvement Commission dredged the river and stabilised the banks with slag. The area was formerly water meadow of great beauty, and the 'improvements' were not seen as improvements at all by those who appreciated the local flora and natural order. Time has healed the starkness brought about by these changes and later generations have known no other. Funfairs were a regular event and up until shortly after the station closed, a café existed alongside the station buildings. Nowadays the emphasis is much more on the space being used as a nature reserve and the opposite bank at Newburn caters more fully for organised sporting activities.

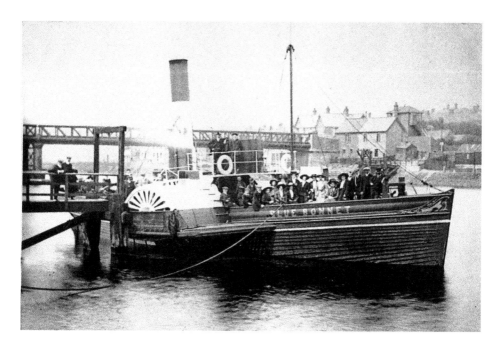

All Aboard for a River Cruise

This old landing stage at 'the Spetchells' was technically in Northumberland because of the way the river had changed its course over time! These trippers are from Walbottle and are going downstream. Going upstream, midway along The Willows were landing steps, used by those arriving for a visit to The Willows and Ryton Village. Ask many an elderly Tynesider today and their sole visit to Ryton has been on a Sunday School outing by boat. The old jetty here has gone, but the University Boat Club uses the landing stage sited at the same location.

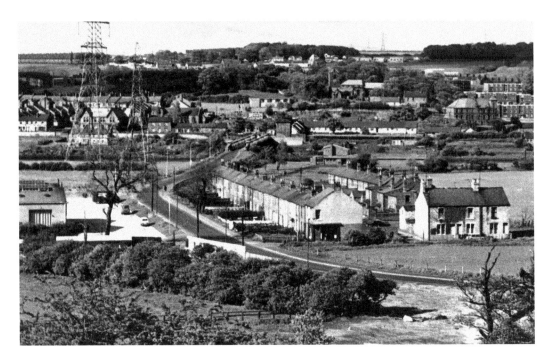

Back of Beyond? – Ryton's Own Klondyke

Officially known as Newburn Bridge End, this isolated community of three terraces and a shop existed on the south side of the bridge until it was demolished in the 1960s. Popularly known as 'the Klondyke', residents tended to work in Newburn, at the Addison colliery or the nearby rail marshalling yards. The housing has now all gone, replaced by light industry as a continuation of the industrial estate complex that follows the Newburn Bridge Road. The name 'Klondyke' has not quite disappeared and is being remembered with a street name in the new Stella South housing development on the site of the old power station.

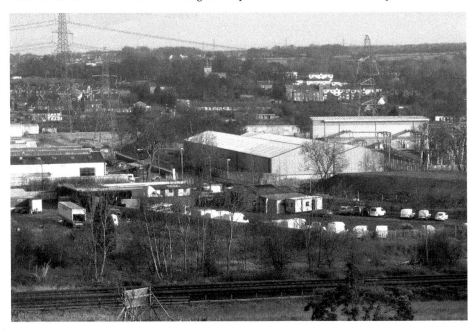

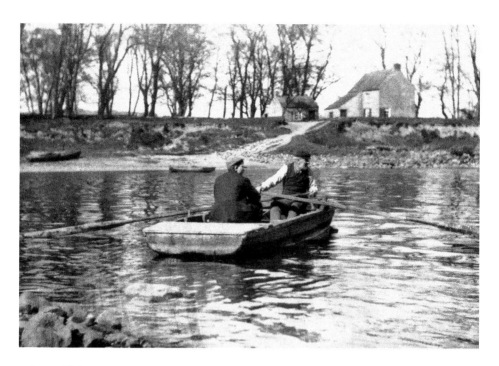

Who Paid the Ferryman?

Anyone who wished to cross the river at this point! We take crossing the river in our cars for granted, but not only did most people walk and therefore needed the most direct route, but many bridges, including the one at Newburn, were toll bridges. Joshua Scott and his father before him were the ferrymen for many years and their house on Ryton Island is pictured above. This was on the north bank, but because of changes in the river's course was part of County Durham! The Ferry House was demolished in floods, but Ryton Island was removed from the map and the landscape when the Tyne was 'improved' in the early 1900s.

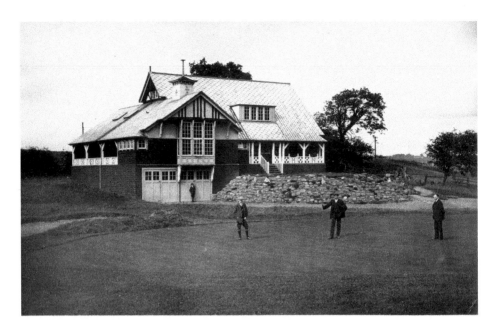

The Auld Established Tyneside Golf Club

The Tyneside Golf Club at Ryton is the third oldest in England. Local enthusiasts had been banned from practicing on the Newcastle Town Moor, but the railway had recently opened up the Ryton area and this proved to be a perfect and accessible location for a nine-hole course. From 1879 to 1903 the land used was at the west end of the Willows, with the entrance and successive clubhouses near Ryton Station. The last of these was taken over by the nearby Ryton Golf Club and transported along the riverside to their site near Clara Vale. Additional land was later acquired and the present eighteen-hole course established in 1911. The present clubhouse also dates from this time, when the axis of the course moved up from the station area to near Westfield Lane.

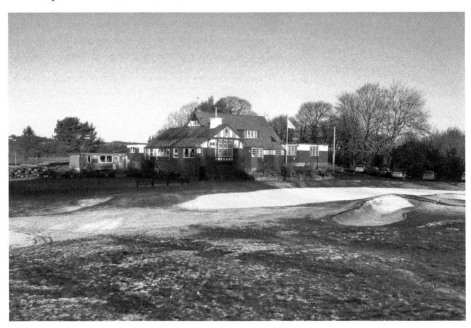

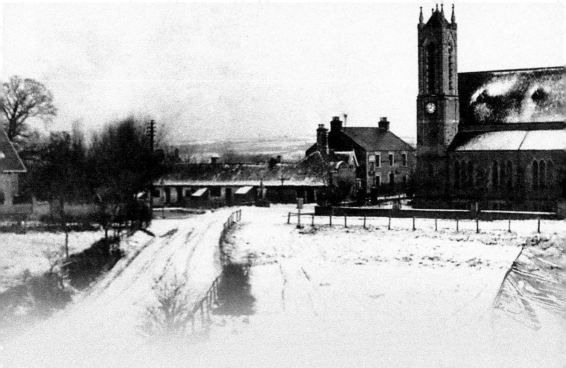

CHAPTER 2

Around Lane Head, Crookhill and Barmoor

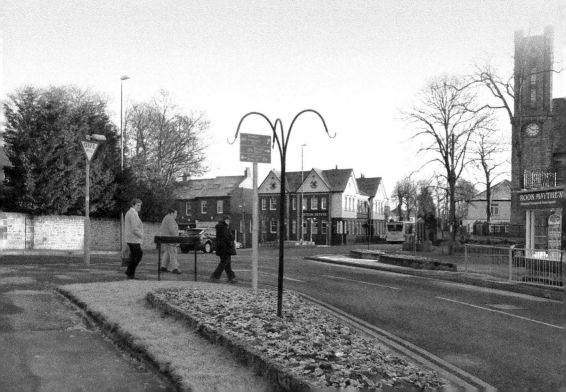

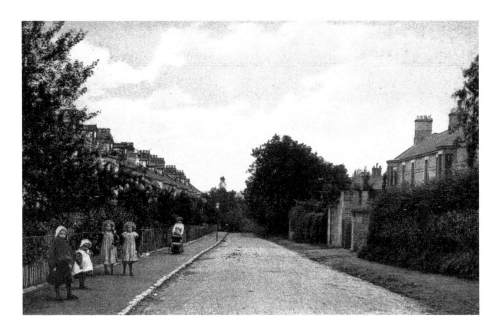

Country Living, St Mary's Style

Our first chapter took us around the old village of Ryton and along the riverside to the north. This chapter visits the residential areas that developed to the south in Victorian times. For want of a better term we have described these as being 'around Lane Head'. St Mary's Terrace and the villas opposite are good examples of this and reflect the influence the railway had in bringing commuters to Ryton. Also in this chapter we visit the colliery communities that ringed Georgian and Victorian Ryton. The size of this book determines they be included here, although their architecture and original residents mark them out as being from a very different world.

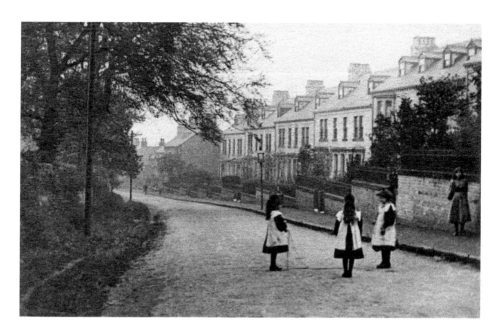

A Perfect Place to Play

The road from the village was formerly known as Ryton Lane, hence Ryton Lane Head. The current name is 'Whitewell Lane', which celebrates the former well that lay opposite the present pizza parlour. The area to the left (above) is still walled, as the picture is from about 1900 and there is no Northumberland Road at this date. Behind the walls there are still open fields and a little further north the Elvaston Hall estate. The elegant Wallace Terrace can be seen on the right. This almost Jesmond-style architecture, but in 'white brick', would have been quite alien to the area when introduced and, as with St Mary's Terrace, reflects the city influence brought by the railway.

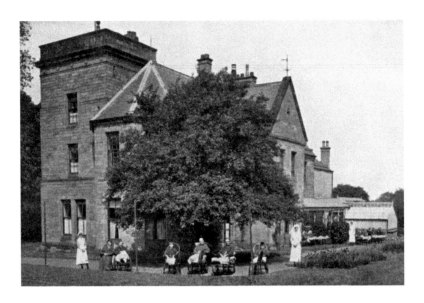

A Tower of Many Tales

This grand residence has more than its fair share of stories to tell and illustrates well the types of owner and use such buildings have enjoyed over time. Ryton Tower was built about 1860 by the Prussian Consul Gustav Schmalz, whose son was the noted artist Herbert Carmichael. A later owner was Major Charles Harrie Innes Hopkins, a founder of the Tyneside Scottish Regiment. Both of the Major's sons were killed in the Great War, after which he donated the tower to the Army as a convalescent home. This was later transferred to the Newcastle Royal Victoria Infirmary until the RVI took over the larger premises at Castle Hill Hall. Until 1974, the tower was used as the offices of Ryton Urban District Council and has since reverted to being a nursing home – for retirement.

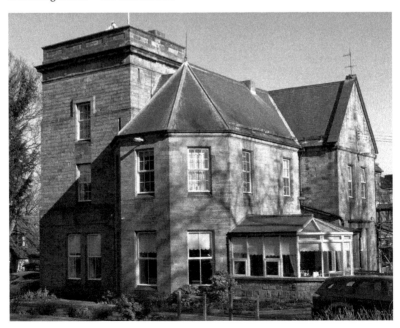

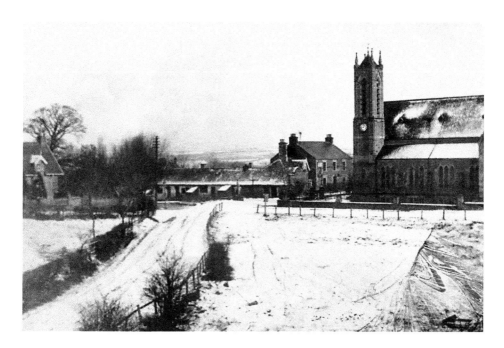

A Victorian Winter at Old Lane Head

The year is about 1895. The new Wesleyan Methodist church stands here in snowy isolation on the south side of the road, having supplanted the pond that formerly existed on the site. All the buildings on the north side are soon to be replaced and the Queen Victoria Diamond Jubilee Fountain has not yet been installed. Things must be looking up. A grander Ryton Hotel is about to be rebuilt, and may just have changed its name from the less distinguished Joiners Arms. Along the lane to the village, five very old cottages still stand. I wonder what tales of Ryton their occupants would have been telling then?

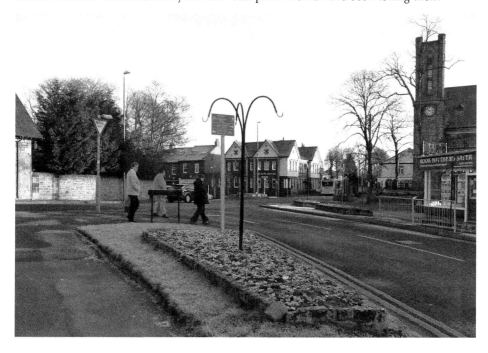

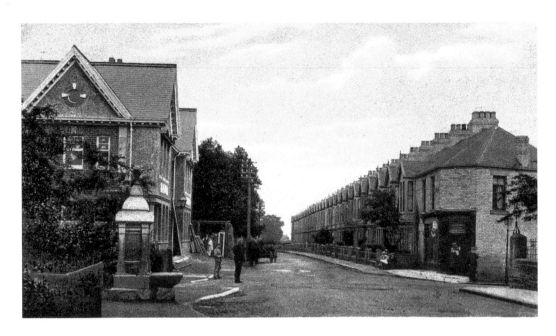

Grass Patch to Fountain, Inn to Hotel

We are now in the year 1910 or just after. The new Ryton Hotel has been built and opposite can be seen the smartly gabled residences of Dean Terrace. Sadly, their uniform appearance has not stood the test of time as the wooden decoration has often required replacement and a variety of styles has emerged. There is an ornate marble fountain crowning the Lane Head, where once there was a triangular grass patch. The fountain was erected to celebrate the Queen's Diamond Jubilee of 1897 and dedicated with great ceremony. Gracing the central point of this district, it survived until 1951 when a brewery wagon ploughed into it and it was dismantled and removed.

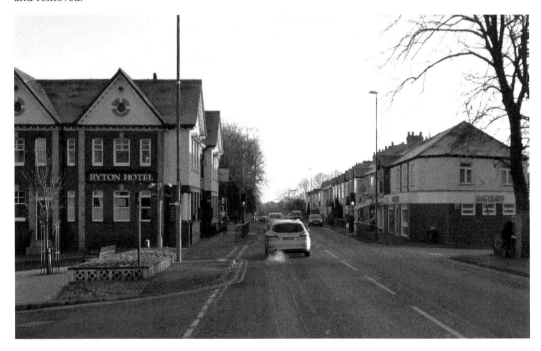

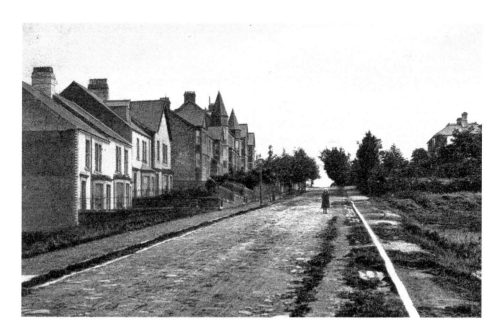

Hill Crest – Going Up in the World

Moving south from Lane Head, Grange Road afforded the professional classes opportunities to purchase property with more space and more distinctive styling than even the Terraces. At the time this photograph was taken, the west (right-hand) side up to Hill Crest is still open. Allotments were later to occupy the land before being replaced by further housing, the clinic and the library. James Scott, a timber merchant, owned the large house known as Hill Crest and planted the trees that still grace the road today. Beyond Hill Crest was The Mount, a detached red-brick residence with large gardens that disappeared under housing development in the 1960s.

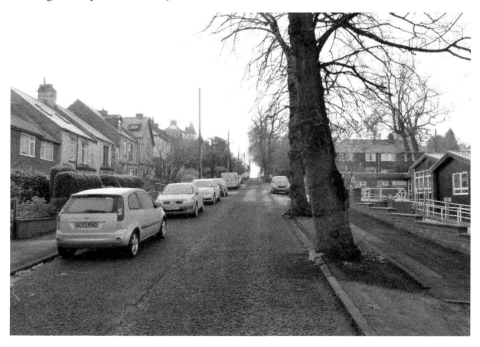

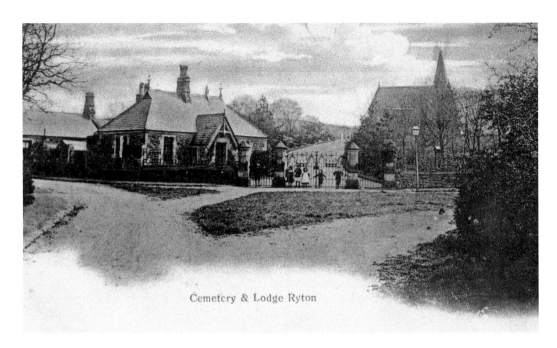

Cemetery & Lodge Ryton

Cemetery Lodge and Chapel

Crossing Lane Head from the north, early transport would have taken the Hexham Old Road to continue the journey towards Gateshead. In 1894 a cemetery was built further along this road by the Ryton Local Board. This was a period when Local Authorities were being required to provide alternative burial sites to church premises. The buildings to the left of the cemetery lodge were used as Council premises before their move to Ryton Tower between the Wars. The local fire engine was housed in the large-doored structure where the car is parked.

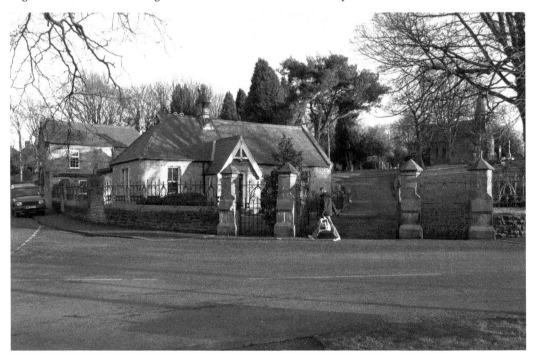

Burnaby Lodge Rail Crossing

Local people today often refer to this whole area as 'Burnaby Lodge' after the house, which was built here around 1890. The scene is rural Ryton of old, with a country lane arriving from Green Gate Bank, Woodside and Greenside and branching off to the eastern and western ends of the old village. In the foreground the railway (better known as the 'Dilly' line) passes from the Emma Pit to Stargate and on to market. Evidence of this can be seen with the 'traffic' lights and the old shelter building on the right, but there are neither level crossings nor any automatic barriers on view here; signs perhaps of a slower pace of life, with fewer vehicles on the road and a different attitude to Health and Safety!

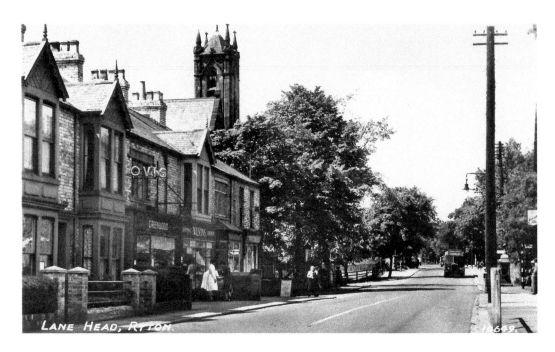

Lane Head Shopping Centre

The old Hexham road followed the route from the cemetery across Lane Head to the village. What we see here is the new Hexham road that used the route of the old wooden-railed waggonway between Barmoor and Stella. You need only compare the gradient of the two roads to appreciate one followed the most level course possible and the other wound round the houses in traditional style. This is the 1950s. The tinted postcard that we saw earlier in this chapter was taken nearly half a century earlier, when only Sandham's corner shop was in business. Since that time, the next few premises have been converted into shops, giving us our present-day array.

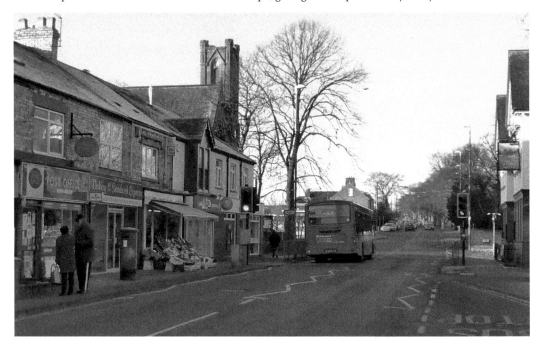

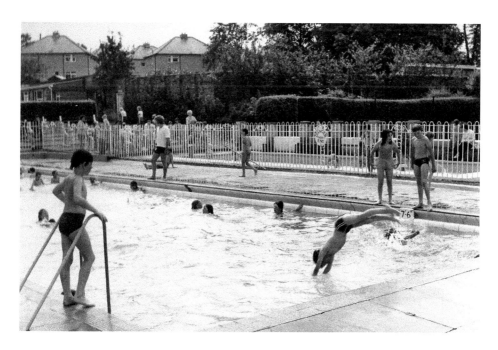

Making a Splash

Ferndene Park was opened in 1956 and provided local residents with a pleasant place to walk and sit, a bowling green, tennis courts, children's play areas, a small shop, an area with aviaries and the much loved open-air swimming and paddling pools. Such pools had fallen out of fashion by the 1970s. A replacement sports complex on the site of the old Emma colliery was planned but failed to materialise. On a more positive note, we cannot leave our visit to the park without mentioning the floral displays. Ryton had a high reputation for the quality of its display work and from the 1960s to the 1990s was awarded prizes in 'Britain in Bloom' competitions including the national award 'Floral Small Town' in 1973.

Barns or Beers at the 'Run Head'

Almost totally lost from our area are the many farms that once followed the main roads in Ryton, Crawcrook and Greenside and existed in the heart of each community. Farm buildings have usually been replaced, their fields prime targets for the expansion of housing estates. Runhead Farm, also known as 'Jackson's', is one such example; the old Home Field became the Holburn housing estate and farm buildings were replaced by the inn. The current Hexham road uses the course of the old waggonway and the 'run head' was literally the head of the difficult inclined 'run' that coal wagons took down to the River Staithes in the Stella area.

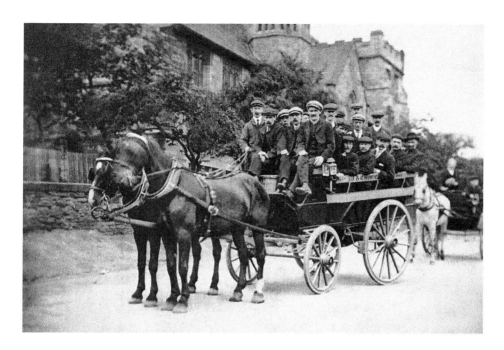

Trip Out with the Howies

We have now moved out from residential Ryton into 'colliery country', courtesy of brothers Jimmy and Bobby Howie from Crawcrook. The backdrop for this atmospheric picture is St Hilda's church at Hedgefield on the main road from Ryton to Stella. It was opened in 1892 in order to meet the spiritual needs of the colliery communities of Addison and Stargate, and the later housing at Crookhill in between. St Hilda's survived the closing of the two local collieries and the demolition of Addison village, but finally closed its own doors as a church in 2005. At the time of writing, the building has yet to be put to an alternative use.

The Lost Village of Addison

Addison village was built to provide miners' housing for those working at the newly opened Addison colliery and pulled down in 1958. It comprised three terraces imaginatively named High Row, Low Row and Cross Row. We see here the roofs of High Row and opposite the buildings of Middle Hedgefield Farm. The farm buildings house a number of walled up windows and doors reflecting the fact that this was home to many families in times past. The census returns of 1851 refer to the occupants of White Cake Row, the delightful name given to these buildings. Points of interest to note are the cobbled road (the date is approximately 1950) and the fact Addison is now an area of managed woodland.

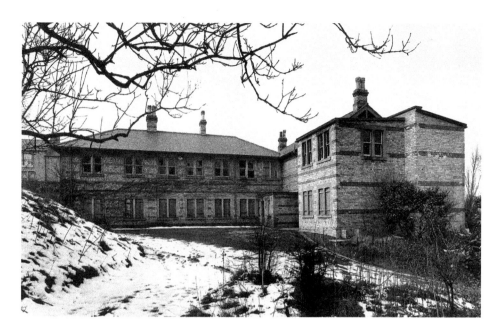

From Payslips to Pizzas

From the 1840s through to nationalisation in 1947, coal mining in the Ryton area was carried out by the Stella Coal Company (SCC). The company expanded considerably at the end of the 1800s. These offices were built to help administer local operations, although the registered offices were on Dean Street in Newcastle. As can be seen from the picture below, the building has since been rendered, but the older image displays the cream brickwork with red stripes favoured by the SCC in the 1890s and the first years of the new century. When the building was no longer needed for colliery purposes it was sold into private ownership and currently trades as Michelangelo's Italian Bar, Restaurant and Hotel.

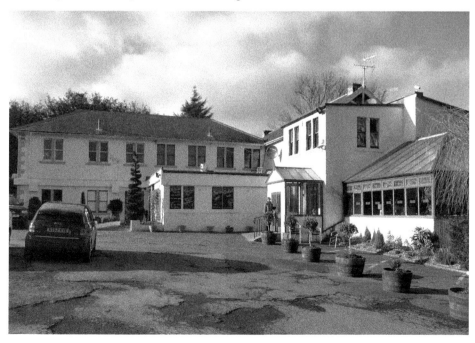

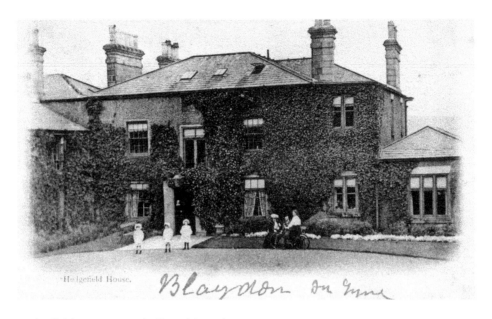

Hedgefield House. Blaydon on Tyne

Hedgefield House: Hospitality with a History

Although the postcard states 'Blaydon-on-Tyne', this may have been for postal convenience. Hedgefield Dene actual runs through grounds of the House and formerly divided the Ryton Urban District from that of Blaydon. This old house is full of history and was built by the Dunn family who mined Ryton coal in the late 1700s and early 1800s. From the later 1800s, it was one of the residences of the Simpson family who dominated the affairs of the Stella Coal Company until it was nationalised in 1947. It also provided working office space for senior officials. It now houses a number of private homes within its grounds and serves as a charming hotel.

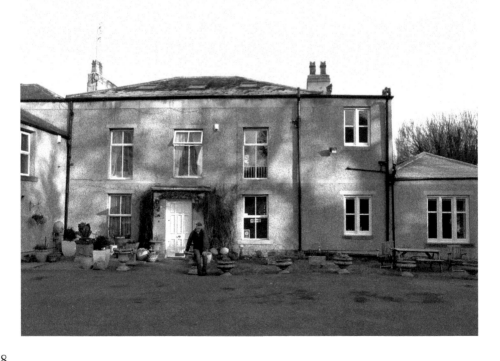

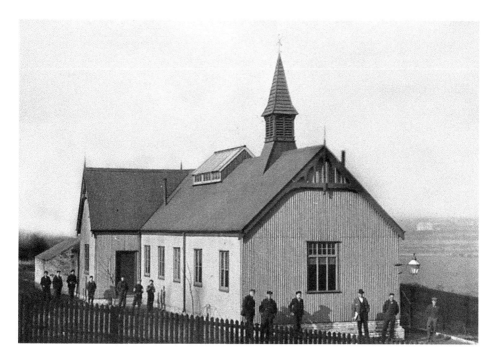

Heart of the Village

The Addison Miners' Welfare Institute, or 'Jubilee' Institute as it was called, was erected in 1897 but burned down in 1930. Among the losses was the Addison War Memorial Roll of Honour. Community facilities included a Primitive Methodist church on Low Roe, and a scout hut and Institute to the south of the rail incline. In the inset picture we can still see the steps of the elementary school on High Row. When the colliery was earmarked for closure, the decision was made to re-house the village's occupants rather than upgrade the properties. All the land occupied by the village was eventually turned over to woodland, as we see here.

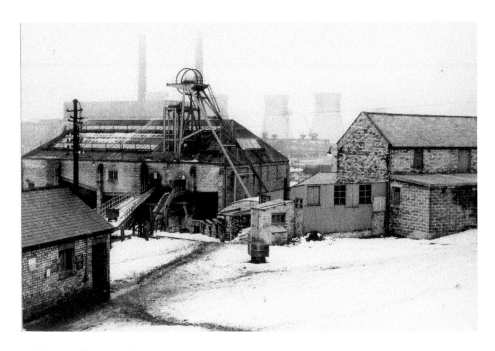

Addison Colliery (1864 to 1963)

Addison village was built on the slopes, Addison industry on the flat land below. This area was very much the hub of the Stella Coal Company's operations. In addition to the colliery, two drift mines and coking ovens, the offices were sited on the main road nearby and a rail incline joined the main line here bringing coal from the Greenside, Emma and Stargate pits. The light industrial estates have taken over the land formerly occupied by coal and rail operations. The former engine shed that can be seen in Stella Coal Company stripes below is one of the few buildings remaining from the previous era. The nearby Stella power stations that operated from 1954 to 1991 can be seen in the background.

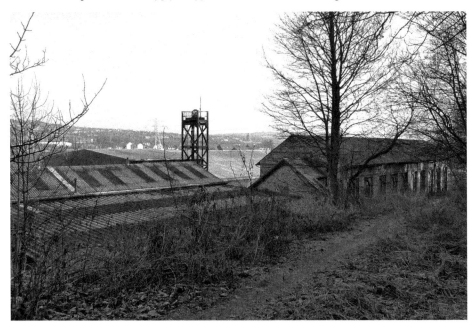

Crookhill's Centre: The School and Co-op

In the first years of the twentieth century, work began on developing land belonging to Crookhill Farm between Stargate and Addison in order to provide additional housing and facilities for the two communities. This 'County' school opened in 1907, providing better facilities and a more supervised educational structure than the small colliery schools in the two villages had been able to do. Next door, a branch of the Blaydon and District Industrial and Provident Co-operative Society had opened in 1901. A variety of departments and facilities were housed on two floors including grocery, bakery, butchery, drapery and hardware, meeting rooms, an events hall and a library.

A Place of Local Reflection

Stargate and Addison each had their own chapels, but the Wesleyan Methodist chapel at Stargate became too small for its congregation and the premises were moved to Crookhill in 1912, where they remained in use until 1980. Behind the chapel site can be seen cream-brick terraces, the first to be built in the new Crookhill area. To the left of the Stargate War Memorial is the crescent of twelve Aged Miner's homes opened in 1921. Outdoor War Memorials can also be found at the Emmaville Hall, in the centre of Greenside, at the entrance to Clara Vale village and at Station Bank, Ryton Village, as well as within various churches; testimony to the very large number of servicemen from local colliery villages who perished.

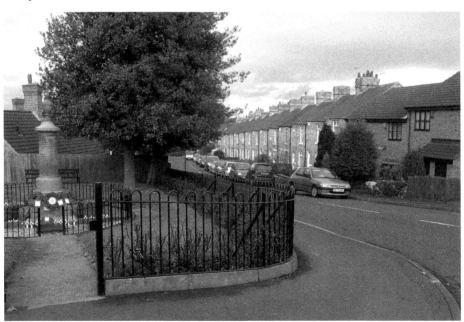

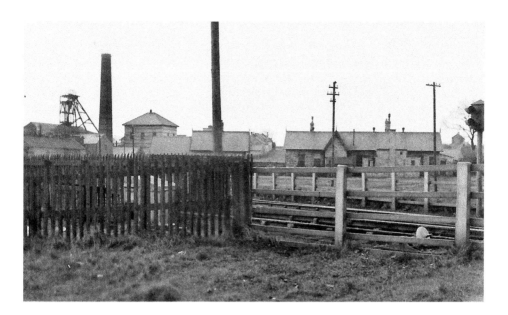

A Hub of Local Industry

Stargate was a major junction for the local mineral lines with coal trucks arriving from Emma and Greenside collieries and then either dropping down to the Newcastle and Carlisle railway at Addison or to the staithes just east of Stella. The line down to Stella Staithes followed the course of an earlier waggonway and allowed Ryton coal to be shipped downriver by boat. The brick supports that carried the line over can still be seen today. The line to Addison passed under the main road east of Michelangelo's Restaurant and operated on an incline system in which empty trucks were hauled up by full ones going down. The photograph above shows the old school buildings to the right and was taken in around 1950. As with Addison, a light industrial estate has been built on the site of the former colliery.

A Stargate Winter

This winter scene was captured in the 1970s and shows the original line of terrace roofs in Stargate before the trend to install dormer attics altered their character. When the colliery was reopened in 1873, five terraces were built and all were designed with front and rear entrances. Between the wars the Stella Coal Company sold many properties in this style to raise much needed income. Nearby Addison was built a decade earlier with nearly twice as many dwellings but mostly of 'back-to-back' design, later considered not worth upgrading. These are two reasons why the Stargate houses have survived, and contributory factors in the decision to demolish Addison. In the background we see the sand and gravel quarries at Liddell's Fell, an important local industry with a big impact on the local environment.

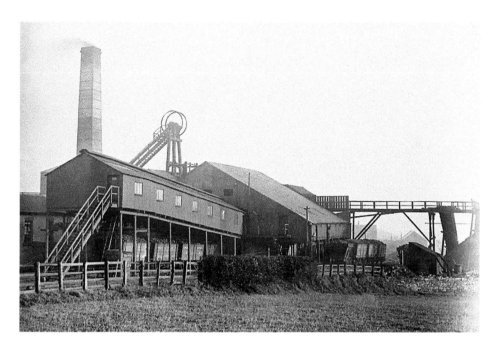

Stargate Colliery (1873 to 1963)

Stargate was the scene of the area's worst mining disaster when in 1828, thirty-eight men and boys perished following an explosion. This Stargate pit had opened in 1803 but closed shortly after the disaster in 1833 following an ownership dispute amongst members of the Dunn family. Stargate colliery was re-opened by the Stella Coal Company in 1873, being the third of their five main collieries after Emma and Addison (Clara Vale and Greenside were to follow in 1893 and 1902). It was the first to close. We can see below that at this point in its journey the modern bypass is using part of the private railway line that ran from Emma colliery.

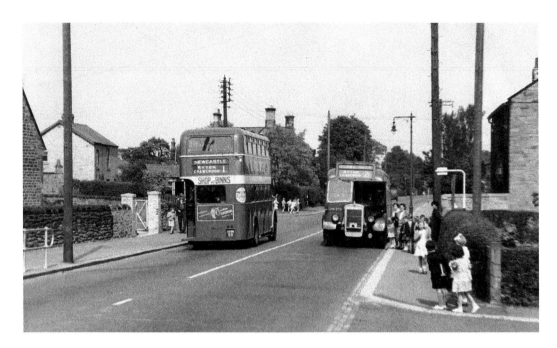

On the Buses

To continue visiting Ryton's colliery communities we now move from Crookhill in the east to Barmoor in the west. In Chapter 1 there was mention of a school in the grounds of Archdeacon Thorp's new residence at Dene Head House in Village West. Thorp was Rector for over fifty years in the early 1800s and had as much influence as anybody in shaping the history of Ryton. In the 1860s this school was rebuilt as the Thorp Memorial School and can still just be seen in this 1950s picture (extreme left). The link was revived in 2011 when the current Secondary School chose as their name: 'Charles Thorp Comprehensive School'.

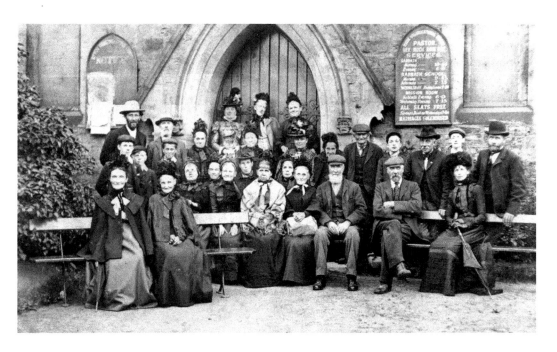

Congregational Church with Congregation

The site for Ryton's Congregational church (later the United Reformed church) was given by the Lamb family of Ryton House and replaced a small chapel that had stood close to the site of the current Crawcrook Social Club. The church stood here as a place of worship from 1861 through to 2010 when the final service was held. An infants and later junior mixed school was run from adjoining buildings until the 1930s. The manse and hall are now used as private residences, the main church buildings as premises for architects.

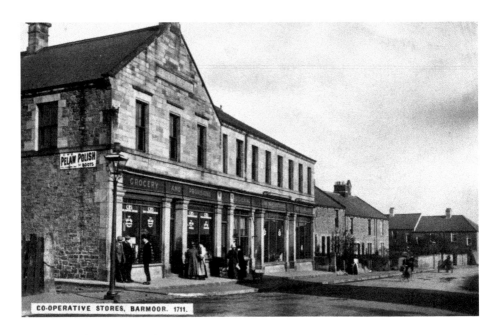

CO-OPERATIVE STORES, BARMOOR. 1711.

Dancing and Printing at the Co-op

Barmoor was once an open, 'bare moor' known in past times as Ryton Moor. It ceased to be quite so bare when the Towneley Main colliery (an early name for the Emma pit) was sunk in 1845 and the village of Emmaville established nearby. The colliery was soon ringed by miners' terraces, which naturally required services. This branch of the Blaydon and District Industrial and Provident Co-operative Society was opened to provide for their needs. In common with similar buildings in our district it provided community as well as commercial services including reading and billiards rooms on the first floor and grocery, drapery, butchering, hardware and boot and shoe departments. Since closure as a Co-op, Beveridge's the printers' and the Hazel Rayson Dance Studio have been the longest established successor businesses.

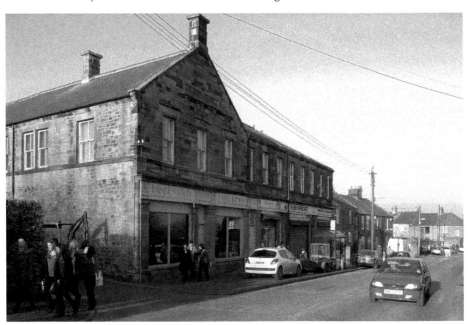

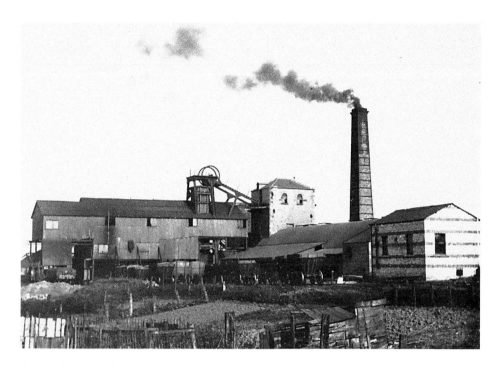

Emma Colliery (1845 to 1968)

It's a strange irony that the most open part of this district was one the centre of the local economy. Today it has reverted to providing the green belt between Ryton and Crawcrook by being once more a 'bare moor'. Emma was the Stella Coal Company's first major investment, sunk by progressive engineers and entrepreneurs at the top of their trade. It was also the last to close. The pit wheel is sited here for aesthetic purposes, as the true location of the shaft was where the path reaches the car parking area. The old Emma site could have been described as 'work with no play'. Nowadays a rugby club, Scout facilities, football pitches and youth centre might suggest the opposite!

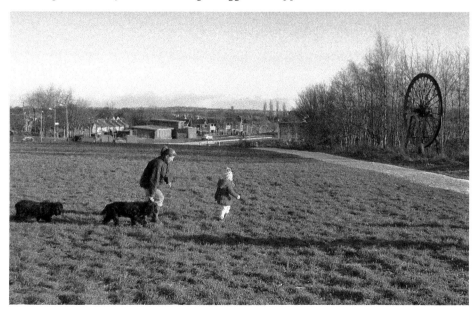

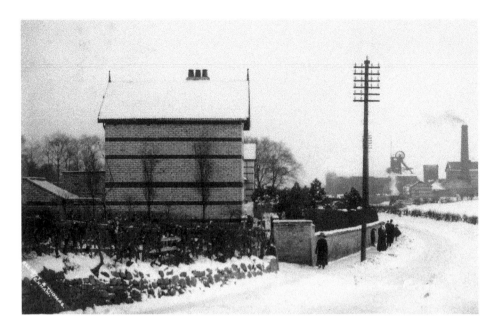

Colliery View

The Stella Coal Company's characteristic red stripes through cream brickwork can be seen on the 'Simpson Memorial Homes' built to provide accommodation for aged miners. The *Blaydon Courier* described these as 'one of the first if not the actual forerunner of such dwellings' and (with Crookhill) '... two of the finest examples ... in Northumberland and Durham'. Three generations of the Simpson family were at the forefront of Stella Coal Company affairs: Robert Simpson, his son John Bell Simpson and his grandson Colonel Frank Simpson, all of whom held genuine respect for competence. Robert lived at nearby Moor House. At different times other family members lived at Hedgefield House, Runhead House and Bradley Hall.

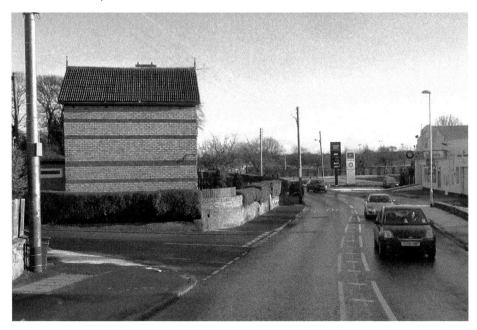

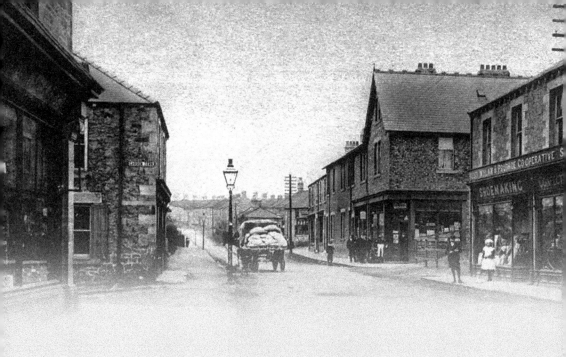

CHAPTER 3

Around Crawcrook
& Barmoor

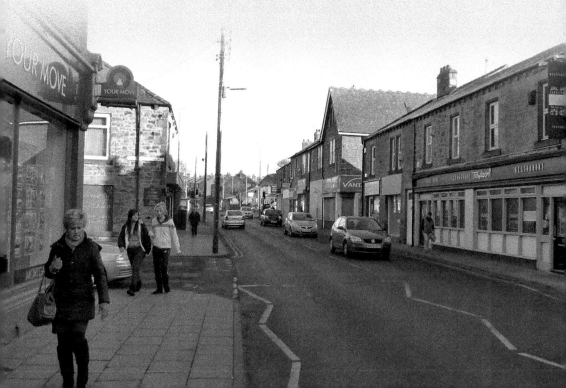

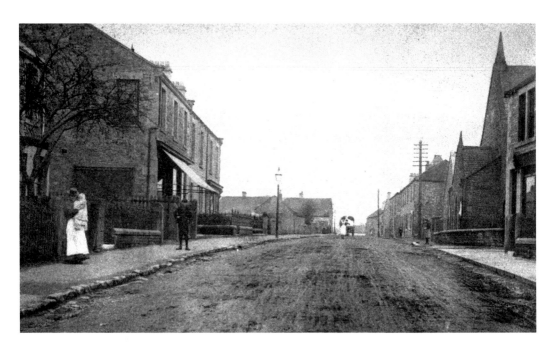

Brow of the Bank

The brow of Beech Grove bank marks the ancient boundary between the townships of Ryton and Crawcrook. In the centre (above) are the cottages of Emmaville, but no Emmaville Hall, as this postcard would be dated about 1910. Emma Colliery Workmens Memorial Hall (a memorial to the war dead) and the Robert Young Memorial Methodist church opposite were both given sponsorship by the Stella Coal Company. Support for community projects such as these was usual and given to all denominations – provided they were alcohol-free!

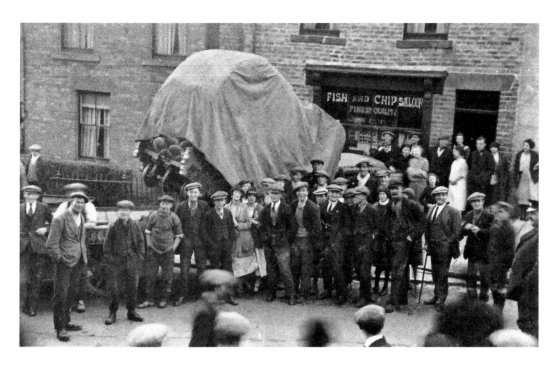

Calling in for a Cod?

The north side of Beech Grove supported a wide range of shops, as this was a main thoroughfare between Crawcrook and the Emma colliery. Since the colliery closure all have had a variety of business ventures trying their luck. At the time of this picture it was Billy Renwick's Fish and Chip Saloon, but this building is also remembered as Storey and Crowes' electrical shop and later still as the DIY outlet. The scene from the 1930s obviously aroused great amusement, but it doesn't look as though any great damage was done; apparently a piece of fairground equipment had broken loose from the traction engine pulling it.

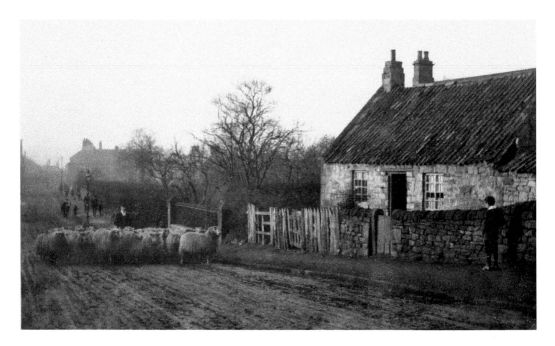

The Old Drovers' Road?

The above scene is remarkable to us because our busy main road is still being used for sheep droving. This point is at the foot of the district that used to be called 'West Ryton' and stretched as far as the colliery at Emma. With all the changes of the past half-century, it's not a term that is in common use today. A static library (replacing a mobile one) came to Crawcrook in the late 1980s, when the swelling of the population caused by the building of the Kepier Chare estate persuaded Gateshead Council that a new library was justified.

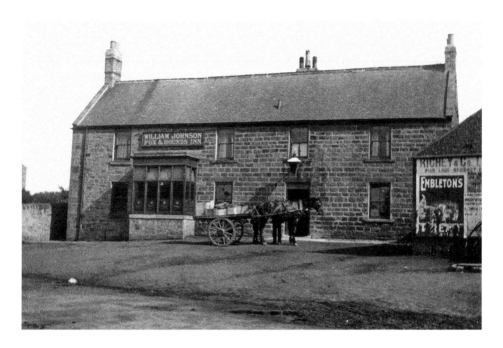

Fox & Hounds

In the 1700s there was a small cluster of buildings around here that included a blacksmith's and facilities for the British Queen stagecoach, but old Crawcrook, (like old Greenside) was a long, straggly community. It ran from the Fox & Hounds Inn here through to Westburn, clinging to the main roads with farmers' fields just behind. A slightly larger settlement existed around the Bank Top (Rising Sun) area. Around 1900, the new colliery terraces started to fill out this land. The large Kepier Chare estate beyond the Fox & Hounds Inn filled one of the last gaps in the open spaces behind the main road.

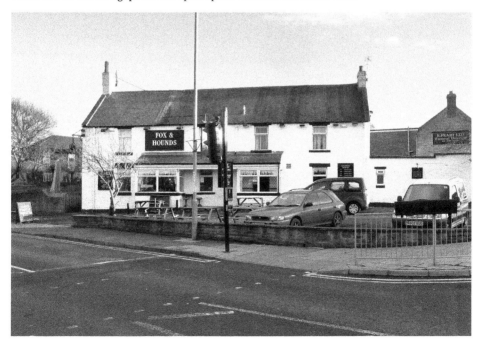

A Different Kind of Flock

The above picture shows Garden House Farm on the north side of Main Street. Farms are also known by their owners so an alternative in recent memory was 'Johnson's' and before that 'Ballantyne's'. As with the Runhead Farm in Chapter 2, Garden House Farm was on the main road and thus the adjoining fields were sought after for housing development. In this case the Garden House Estate was created as well as Crawcrook Park. A corrugated-iron structure further west on Main Street served as an Anglican Mission church for a number of years before the new Church of the Holy Spirit (C of E) was opened on the farm site in 1967.

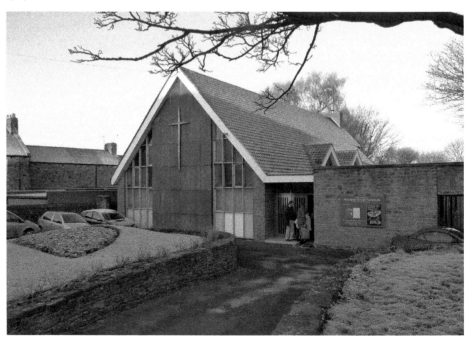

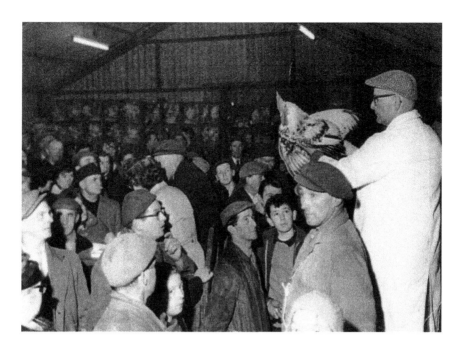

Bargains at Tommy Patt's

Few characters have left their mark on Crawcrook more than the Tommy Pattinsons, father and son. In the inter-war period the Stella Coal Company was selling properties to raise revenue. Where residents did not wish to buy, the Pattinsons offered to become the landlords and so developed a considerable portfolio of Crawcrook houses. Pattinsons' auction houses were bought by Anderson & Garland, who traded in the original wooden huts until new and slightly more modern premises were opened at Westerhope in 2005. The fields stood empty for several years before Crawcrook Health Centre was opened with improved parking and the chemist shop integrated within.

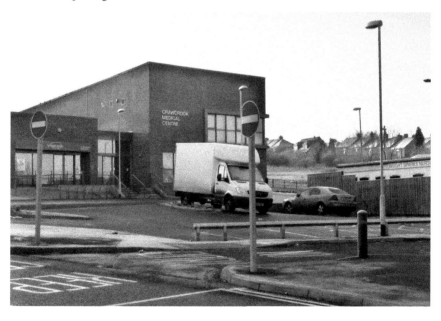

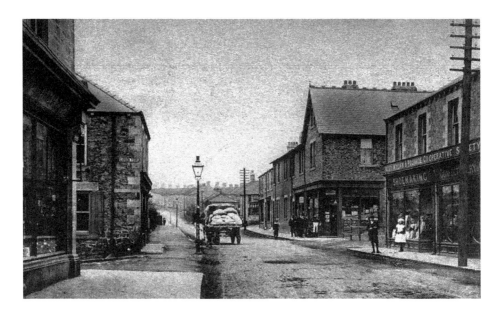

A Cluster of Co-ops

Two rival Co-operative Societies operated in our area. In Crookhill, Barmoor, the Folly and Clara Vale, the Blaydon CWS held sway, but here in Crawcrook and Greenside the West Wylam and Prudhoe Society was king. The departments of the Crawcrook Co-op occupied a cluster of buildings on both sides of the main road, as well as a sub-branch on the Greenside Road. The location of each department did change over time. Local residents remember the present Indian restaurant building housing the bakery and the greengrocer, although the bakery later moved to the other side of the road. The boot and shoe department is shown here at the end of the block, but is also remembered as part of the main building.

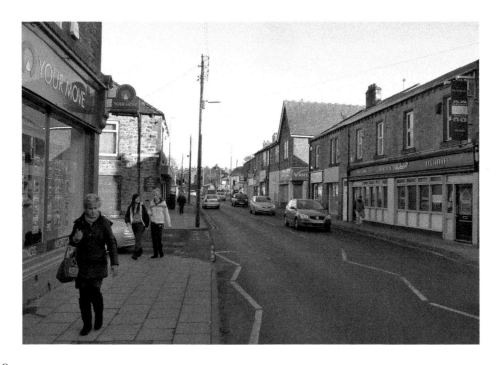

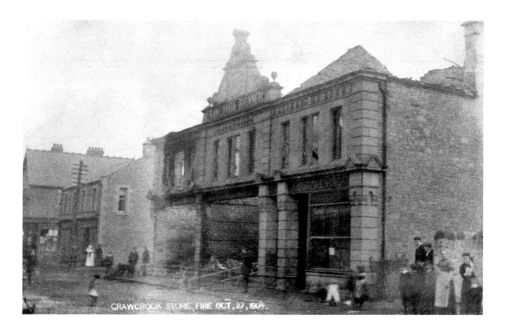

CRAWCROOK STORE FIRE OCT, 27, 1904.

Fire!

In 1906, James Patterson, twenty-six and manager of the drapery department, was charged with 'feloniously and wilfully setting fire to the Crawcrook branch of the ... Society'. The drapery, butchery and grocery departments were burnt out and £8,000 of damage done. Local legend has it that there were great celebrations as the building burnt, as with it went all records of money owed by customers! In more modern times the main building is remembered as consisting of offices, billiard room, reading room and cobbler's upstairs. Downstairs was the main grocery and provisions store in the centre with the butchery on the Prudhoe side and the drapery on the Emma side.

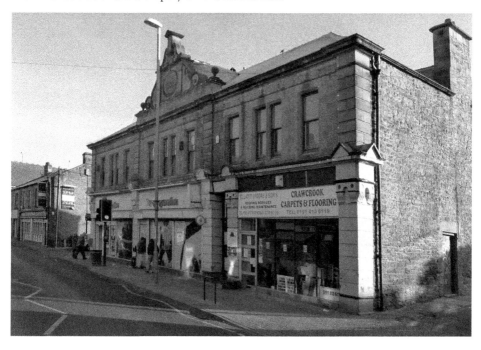

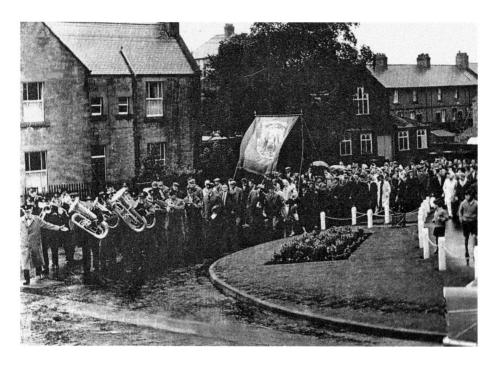

On Our Way to the Gala

The image above shows the Ovingham Brass Band with the Clara Vale miners, plus banner. The date is about 1962 and they are heading for the buses at Emma en route to the Durham Miners' Gala. Over the road is the former Catholic Club (at present boarded), which started life as the Presbytery to accommodate the Catholic priest. The old corrugated-iron church can be seen in the centre. This was still in use as a parish hall for nearly thirty years after services were removed in 1959 to the new St Agnes church. This was sited on Sheep Hill above the new road to Prudhoe.

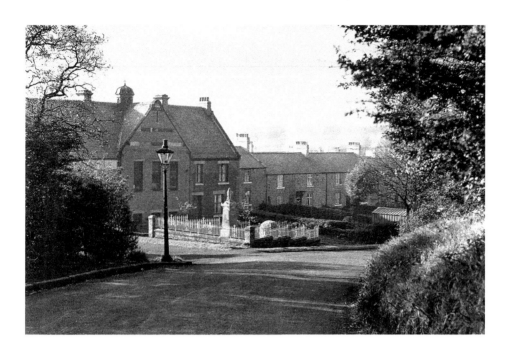

Welcome to Our World

The present entrance to Clara Vale greets the visitor with a canopy of trees and a well-appointed row of stone cottages. This pretty vista is also tempered by a disused Co-op and an over-full War Memorial, reminders of the very different past enjoyed by this isolated community. Clara Vale's prosperity has gone full circle. Built in boom times with a higher standard of colliery house to attract miners, Clara Vale declined to become a pitless village, miles from anywhere with few facilities and where you could scarcely give away the houses. In a changed world it is now a 'retreat' village that many dream of living in.

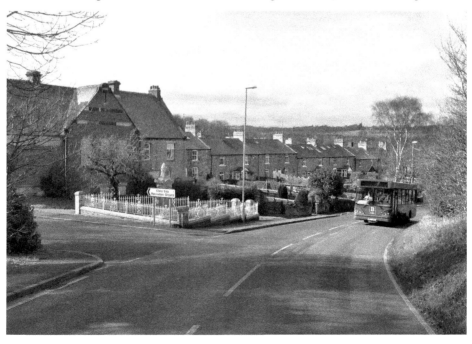

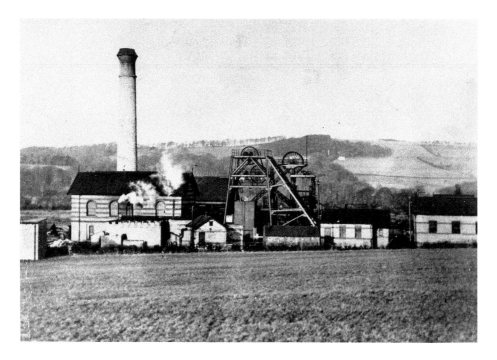

Clara Vale Colliery (1890 to 1966)

Winning coal required considerable technology and Clara was always known as a wet pit. On average it pumped out 10 million gallons of water per week. In common with other local pits, the coal seams were of high quality but thin. This did not allow them to adapt well to the increased mechanisation that the industry was demanding after nationalisation in 1947. When Clara closed, miners who wished to continue their trade were obliged to travel to the coastal collieries or relocate to the Yorkshire or Nottingham coalfields. With the exception of the Ambulance Room, the colliery site has been totally cleared and is now managed as a nature reserve.

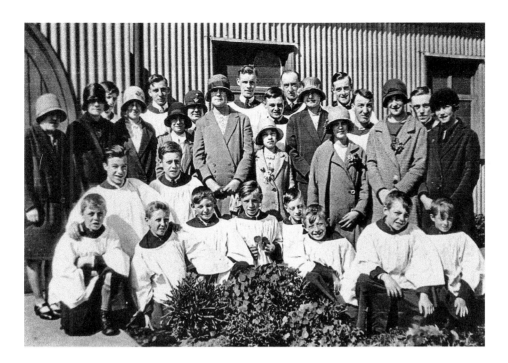

Church of the Good Shepherd

The old corrugated-iron church stood in the grounds of what is now the Memorial Garden. For twenty years before the war it also boasted a wooden church hall to the north. Low congregation numbers and a deteriorating building spelt bad news for the Anglican community. In 1978 the decision was taken to demolish Clara Vale's Church of the Good Shepherd, although the congregation continued to hold services at the Methodist chapel for some time afterwards. The garden has since been created using the outlines of the old church to give structure to the site plan.

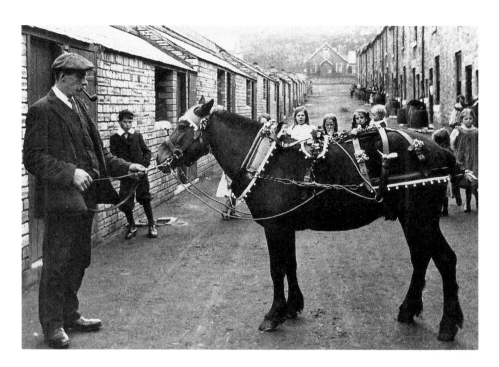

All Dressed Up for the Show

Here a local pit pony is being prepared for show in the back lane of West View. Note how the back lanes look quite different from their appearance today. No private yards, toilets, coal bunkers or pantries have been built onto the terraces yet. This was a trend that took place all over our district in around 1910, replacing the middens and other structures across the lanes. At the end of the terrace can be seen the original Methodist chapel, now the hall belonging to the newer stone-built chapel further west.

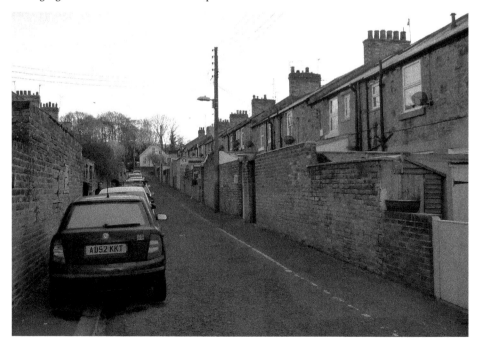

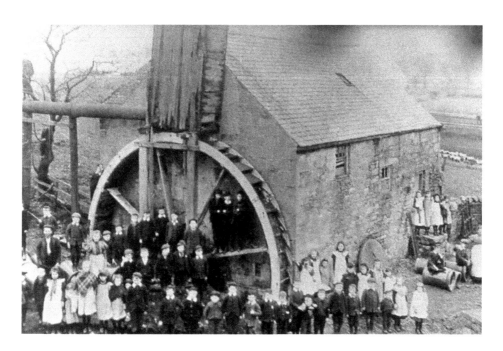

Glenny's Mill

Like Addison, Stargate and Emmaville, Clara Vale was a new settlement created around a new colliery. Prior to this, the mill was all the 'industry' that existed in this area on a route that crossed the Tyne at Stanners Ford, used by local farmers from both banks of the river. Crawcrook Mill was its official name, but onetime ownership by a Glendinning resulted in the more popular name of 'Glenny's Mill'. Both the mill and the nearby Stanners Cottages fell into disuse in around 1900.

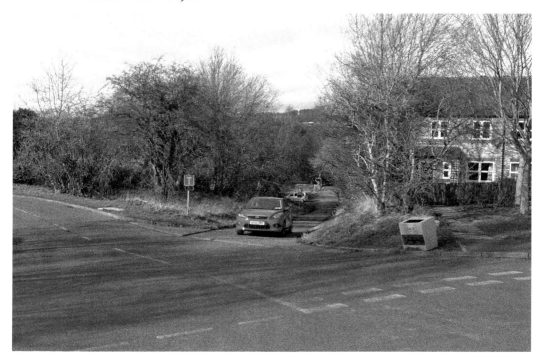

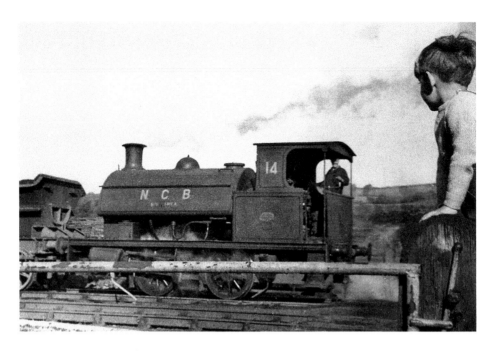

I Wish I Could Drive That!

The district's collieries at Emma, Greenside and Stargate were served by a private railway that connected to the Newcastle to Carlisle line; Addison and Clara collieries were already sited next to it with sidings linking in. A short connection brought coal in tubs from the shaft for screening alongside the main line and from here it was dropped into waiting trucks and carried on to market. Also on the far side of the line were the colliery spoil heaps, now cleared and the land reused by the Ryton Golf Club (not to be confused with the nearby Tyneside Golf Club). The greens can be seen (below) beyond the trees.

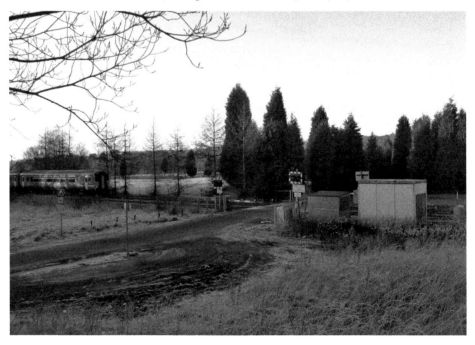

Castle on the Hill

Castle Hill was built by Archibald Dunn, a member of the family mentioned in Chapter 2, but an architect this time rather than a coal owner. As time went on, such grand houses became increasingly impossible for individuals to maintain and the house was eventually bequeathed to the Royal Victoria Infirmary by the Stirling Newall family, who had taken over the premises. It is mostly remembered as a convalescent home and the picture above was taken during this period. Castle Hill Hall has since been sold back into private ownership. The parkland in front has been maintained, but with the main buildings subdivided and additional properties built within the grounds.

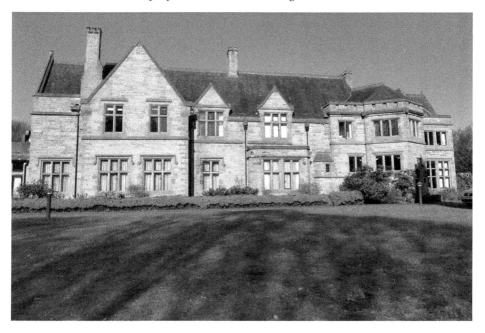

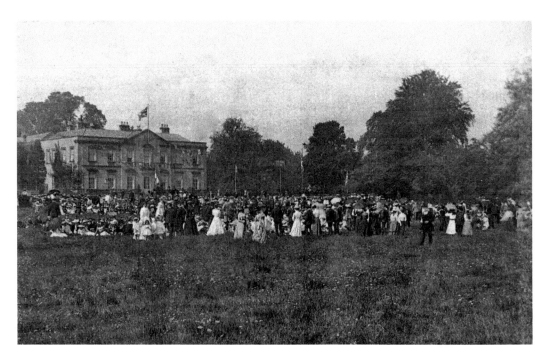

Bradley Hall

This event celebrated here is the end of the Boer War. Bradley Hall is the district's grandest mansion, set in acres of parkland and was originally built, (as so many were) as a country retreat for a Newcastle merchant. Appropriately it was later owned, and still is, by Ryton's coal-owning dynasty, the Simpson family. Unlike many of the area's larger houses its grounds and buildings have been maintained, although the premises are shared with residents other than the Simpson family.

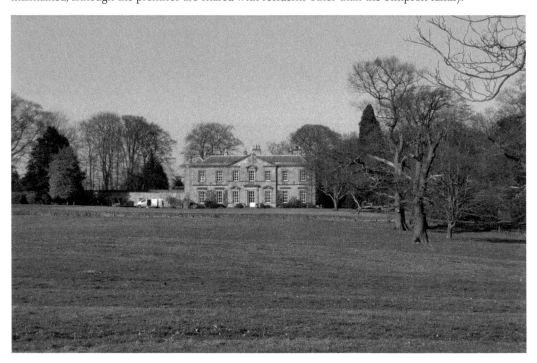

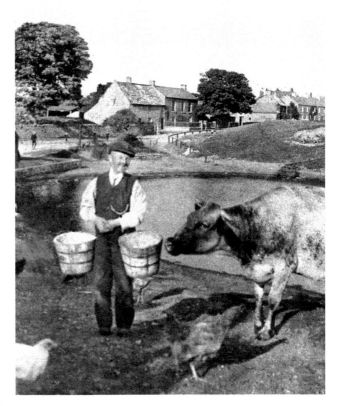

Tommy Oliver and Friends
The picture above of farmer Tommy Oliver with livestock shows us the Wesley or Wisely Pond before draining, with the old farm buildings in the background. Tommy farmed with his son Harry at what was known as Crawcrook West Farm. No longer a farm, it is now 'the Steading'. The pond is likely to be the result of flooded workings from the Wisely pit, which was mined in the 1700s and filled in after the Second World War. The mound is likely to be the result of spoil from the workings. The connection with John Wesley preaching on the mound is very speculative. Wesley did visit and preach in the area, but there is no hard evidence he preached on this precise spot.

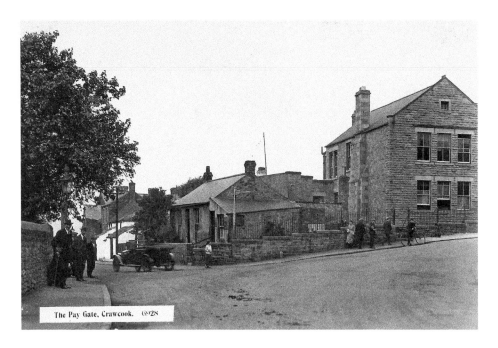

The Pay Gate, Crawcook. 6928

No Left Turn

This postcard by Johnson's of Gateshead shows us a 'T' junction rather than a crossroads; evidence then, that it was taken before the new road was cut through to the west in 1933. On the right of the picture (above) can be seen the Crawcrook Club's extension, built in the early 1920s onto Poplar House. The building work required removing the old Paygate Cottage, which had been needed in the days when tolls were collected for using Turnpike roads. Popularly known as the 'big club', it started life in 1903 in two terraced houses on Beech Grove Terrace, before moving to the present site the following year.

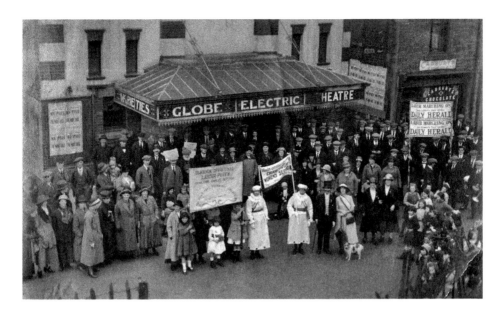

Global Issues

Crawcrook's first cinema was the Picture Palace (opened 1910), later called the Victory and lastly the Queens. Little more than a corrugated-iron shanty in a field behind the Fox & Hounds Inn, it burnt to the ground in 1929. The Globe (opened 1912) was, by contrast, brick-built with a slate roof and lasted as a cinema until 1960. The premises are being used here for a local political rally. Such meetings were mainly those of the Labour Movement, but also included the Irish Labour Party and miners' meetings. Concerts, wrestling bouts, and fundraising events were also held here. And of course there was the staple diet of weepies, westerns and children's Saturday matinees. The building is now used as a garage, with two smaller businesses occupying the former foyer area.

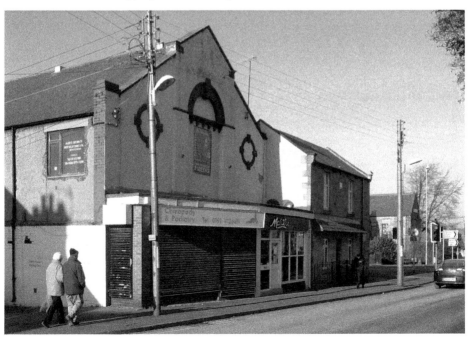

Lambs to the 'Slaughter'?

The Lamb's Arms Inn was named after the Lamb family, major landowners in the Ryton and Crawcrook area. The pictures are taken from the bottom of the gardens of Morgy Hill West. At the time of the postcard, sand was quarried from the lower area and the land above was part of Priestley's Farm. This was the scene of the 'Battle of Morgy Hill', an incident during the 1926 strike, in which certain miners chose to hurl stones and bricks at reservist police from Hull who had been billeted at the Lambs Arms. Unfortunately their ammunition ran out and the resulting chase resulted in broken legs and arms, and much criticism of behaviour all round.

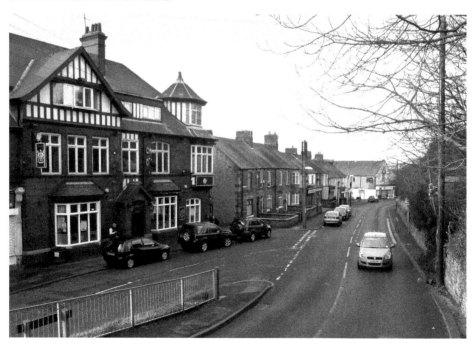

Morgy Hill Merriment

Major national events have always encouraged local celebrations and here we see the street party to celebrate Queen Elizabeth's Silver Jubilee in 1977. The terrace in the background is Clifford Gardens; that to the right is Iris Terrace. These terraces were built in around 1900, as the coal industry expanded and Crawcrook was developed as a dormitory settlement for miners at the Emma and Clara Vale collieries. Iris Terrace was built to a higher standard and at a more elevated position for the use of colliery deputies.

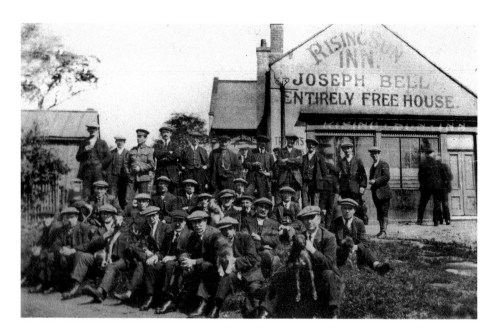

Centre of Old Crawcrook

Although the centre of Crawcrook is now seen to be around the shops on Main Street, this was only so after the village was expanded. Here at Bank Top, the Greenside and Hexham Roads separate and were crossed by the old coal waggonway that ran from the fells to the river. This was a more traditional hub of the village in the era before the 'big pits'. The Rising Sun was always a miners' drinking pub and was also where miners were hired. There was an important blacksmith's here, and at different times the inn was used as a post office and a coaching house.

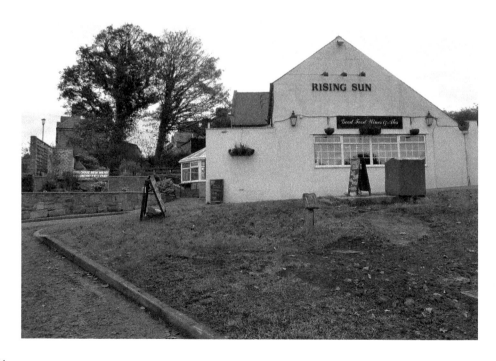

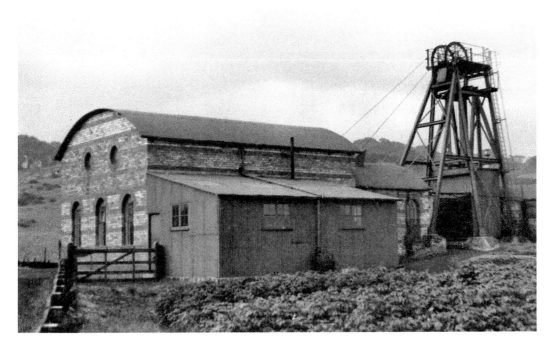

Going Down – at the Catherine Pit

Towards the end of its life, coal drawn at the Emma pit was being mined in the far west towards Prudhoe. There had been a seventeenth-century Catherine pit, but this one was only a 'man-riding shaft' used to cut the miner's journey time to the coalface. The shaft is marked by a small concrete triangle and is on a main route of the old wagon-way system. This can be seen by the embankments or 'batteries' built to provide a level course. The Catherine pit closed in the mid-1950s when the Stanley Burn drift mine opened.

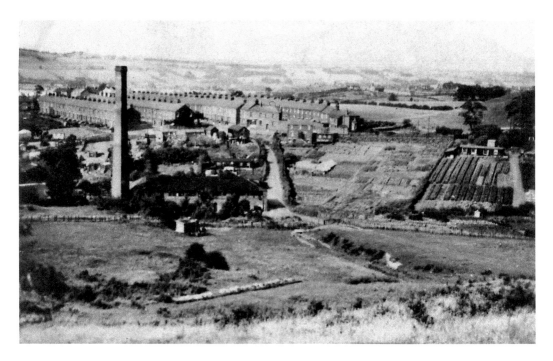

View from the Fell

A number of features stand out in our older photograph that do not appear later. Our chimney belongs to the Phoenix brickworks, a small independent manufacturer later taken over by William Leech as the Newcastle Brick Company. The Ryton Crawcrook bypass now cuts across the centre of our picture, next to the market garden visible to the right. This was typical of market gardens in the area, which supplied local shops before the advent of supermarkets and sophisticated transport networks. The pictures are taken from the hillside, where shale and coal could be obtained for brick making, and which marked the entrance to the old Phoenix drift mine.

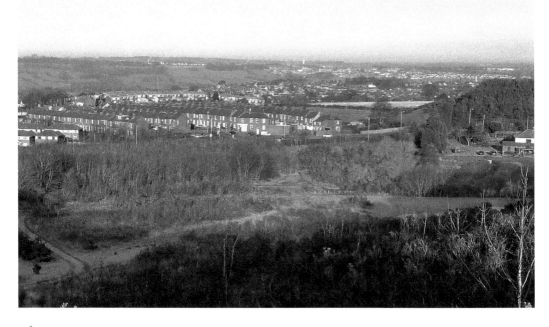

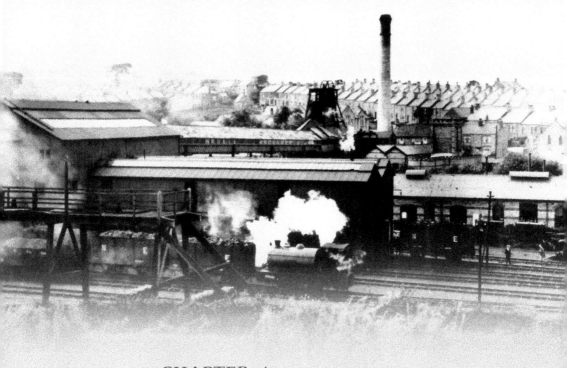

CHAPTER 4

Around Greenside

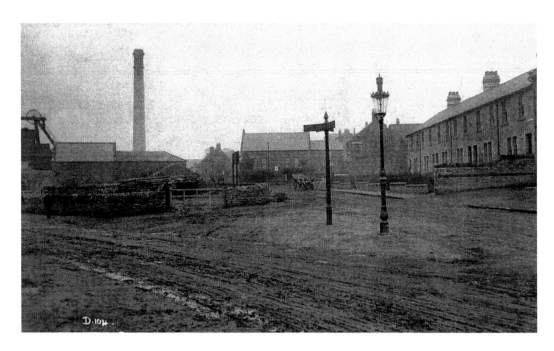

Signpost to History

Here by the War Memorial the main strands of Greenside's story are interwoven. The signpost points towards the newly-opened Greenside pit (1902–1966), which replaced an earlier coal mine (1795–1831) on the same site. To the right of the chapel, Rockwood Hill Road leads to Greenside's earliest coalfield, which was served by wooden-railed waggonways (1600–1800), and to the left is the Lead Road, down which lead ore used to be brought by pack-horses from the North Pennines to the Tyne.

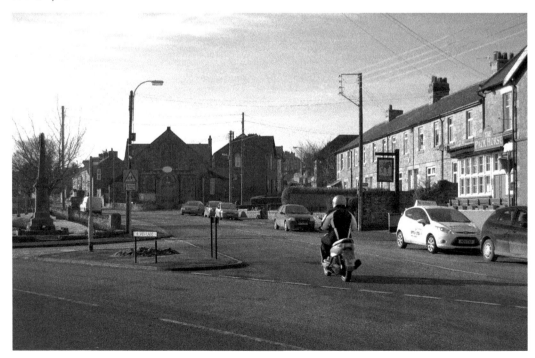

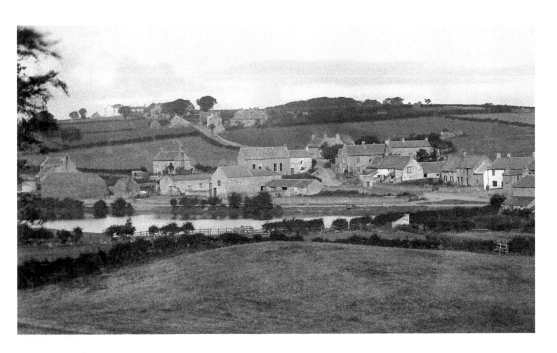

A Rural Retreat

Coal mining and agriculture have always intermingled in Greenside. Beyond the field in the foreground is the Engine Pond, dug out for the 1800s pit. In the back is Rockwood Hill, site of the many bell-pits of Greenside's very first colliery, the Stella Grand Lease. Beyond the pond is Todd's Farm. The picture below shows how the houses built by the Stella Coal Company came to dominate from the early 1900s.

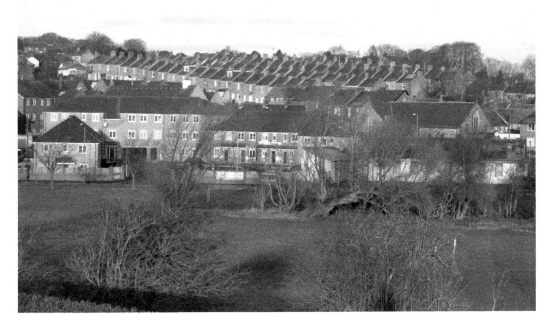

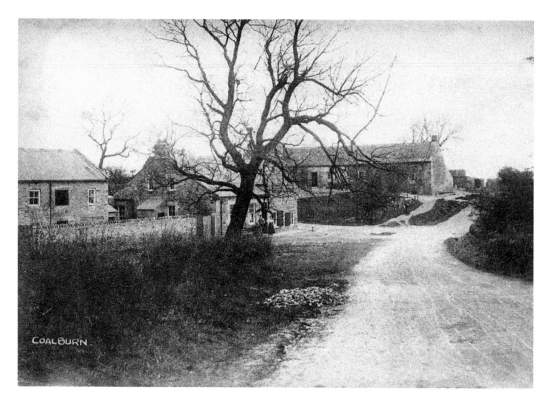

Gateway to Greenside

Just before Greenside, the trains of packhorses (and later the Chopwell or Clavering waggonway) coming down the Lead Road would pass through Coalburns, where the Fox and Hounds also welcomed the huntsmen of the 'Braes of Derwent'. Upstairs in the building next door the Primitive Methodists used to meet. Coalburns as a settlement, centred on Coalburns Farm (also called Brass Castle), dates back to the 1300s.

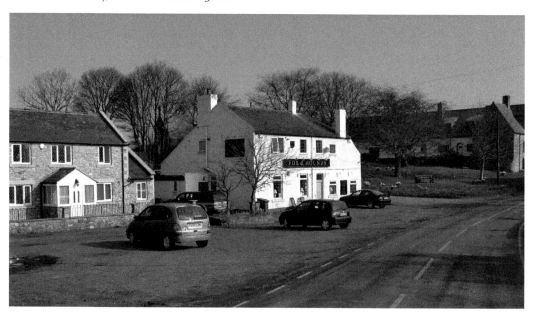

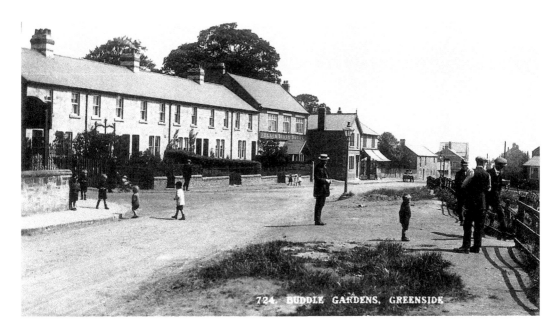

724. BUDDLE GARDENS, GREENSIDE

Black Horse or Pack Horse?

Buddle Gardens is at the left with the Pack Horse adjoining (centre). In the old picture, however, it is called the Black Horse. During the legal proceedings following a fight at the inn, a judge asked for the deeds to be produced. They showed that the inn's original name was the Pack Horse and so the judge ordered that it should be changed back. Buddle Gardens was named after the Viewer (manager) of the 1800s pit. His successor was Thomas Hall, whose son Thomas Young Hall was renowned as a mining engineer in the UK, America, and Russia.

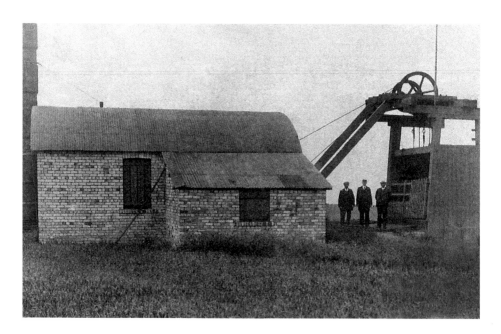

Landsale

Continuing down the Lead Road, you come to Landsale Bank. The pit here, the 'B' pit, opened in around 1800, at much the same time as the bigger pit up the road. Its shaft was used as ventilation for the later Greenside pit. Local children going past the circular retaining wall would tell stories of the ghosts at the bottom. So what did 'landsale' mean? Coal from the big pit was mostly exported by sea to London and Europe, and was called sea-coal or ship-coal. 'Landsale' referred to coal sold locally – mainly to the expanding industries of Blaydon Burn. The modern houses across the present football field are in Younghall Close.

On the Drovers' Trail

The gateway to Greenside from the north by the main road from Ryton is the village of Woodside, formerly as much accustomed to drovers and their cattle on their way south across the Tyne as to coal-carriers. This is Green Cottage, just across from a lost village green, and near a lost pub called The Green Tree and a school for the drovers' children founded by Mrs Thorp. When the nearby Glebe Colliery opened in the early 1800s, Woodside became an important part of mining history, because it was here that Thomas Young Hall introduced several important innovations in mining technology, with the help of Mr Lawson, the blacksmith landlord of the Rising Sun in Crawcrook.

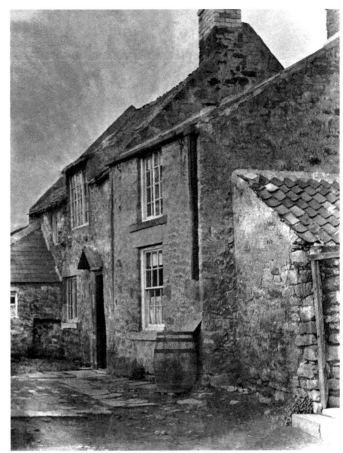

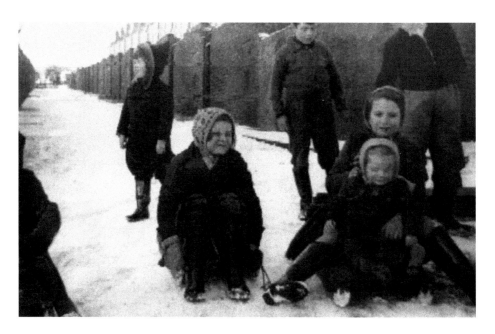

Life in Greenside

Central to the life of the community were school, shops, sport and leisure activities, places of worship, and of course the work of the miners. The picture of children sledging at the back of Meldon Terrace on Rockwood Hill gives a flavour of life outdoors before cars took over not just the main roads but the back streets. In the brickwork you can still see traces of where the old coal-holes used to be for delivery of the miners' free coal into the coal-house, next door to the 'netty' or outdoor toilet in the back yard.

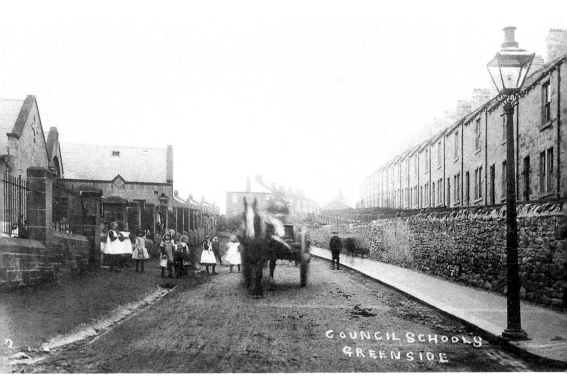

School's Out

Rockwood Hill Terrace is on the right, and just opposite is the primary school. Both are now 100 years old. Greenside School, however, started life in 1813 on Landsale Bank. A huge influx of miners' families after 1900 led to the leaky, overcrowded old building being demolished. So many children were under-nourished and unfit that the new school had a 'marching corridor' – an indoor exercise area. Miners from the terraces on Rockwood Hill used to get to the mine by crossing the school playground. Nobody complained!

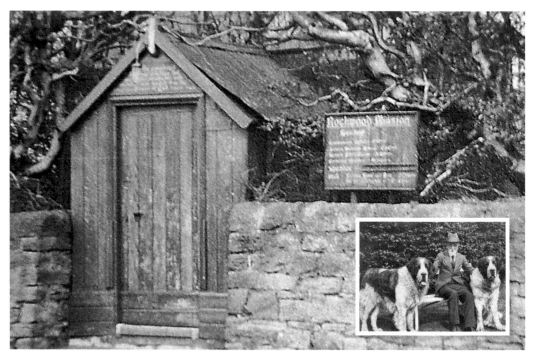

School Again on Sunday!

Mr Hopwood, who lived in the big house which bears his name on Rockwood Hill, was well-known in Greenside and popular with the children who went to Sunday School at his Mission. After being inspired to evangelism in 1887, he established the Mission just up the hill past his house. It is known that even children from Catholic families attended when they should have been going down to Sunday School in Crawcrook. Mr Hopwood helped to instil moral values by encouraging healthy outdoor activities with cycling and camping trips.

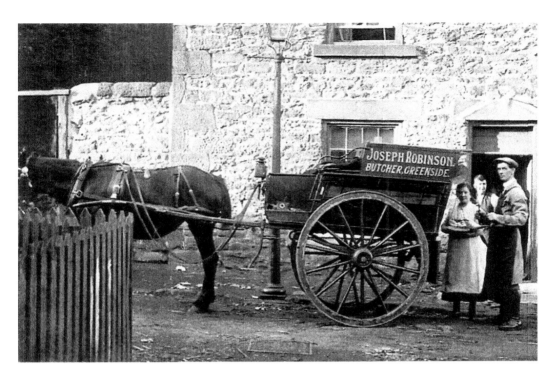

The Shopping Experience

So many little shops have now disappeared; it is difficult to remember how many once lined the streets of Greenside. Yet some traditions die hard. Mr Wishart of Rockwood Hill, like the Robinsons of Folly many years ago, still delivers meat around the rural area, and not only that, but still raises and slaughters his own cattle. Mr Wishart's father took over from the Halls when he first arrived from Scotland.

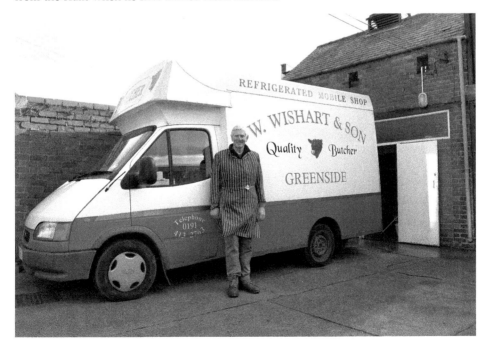

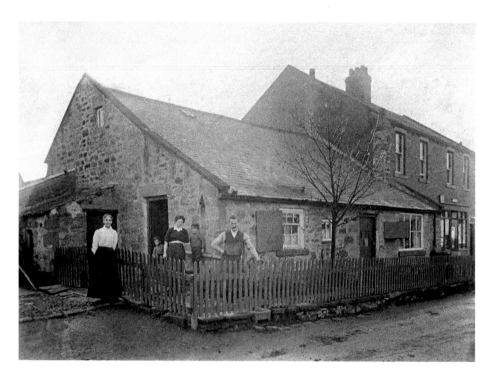

An Irish Connection

The McVeighs, on the other hand, came from Ireland back in 1821 and eventually set up a shoemaker's business in Greenside in the workshop shown above. The McVeigh family married into an already well-established Greenside family, the Marches. In the 1820s, John March was an important cattle-dealer and landlord of the Rose and Crown. More recently, the Phazeys married into the McVeigh family. The house next door to theirs was formerly occupied by Lloyd's Bank.

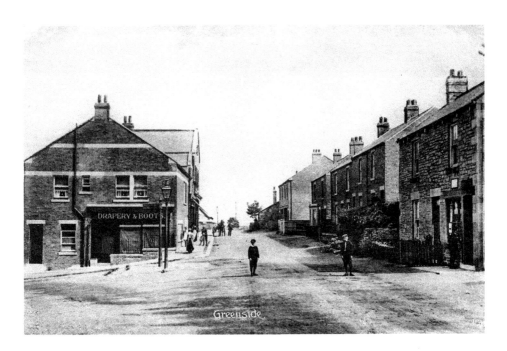

Waiting for the Divi

Greenside had its own department-store, the Co-op (West Wylam and Prudhoe Society), one of three Co-op shops in the village, always popular for the dividend paid to members. As well as the Drapery & Boots department shown in the photograph, there was meat, grocery, furniture and hardware. Just over the road, the shop-front of Nesbitt's is now preserved in Beamish Museum. The Library van reminds us that Durham County Council once ran a lending-library in the Miners' Institute (now the Community Centre) whose roof appears just to the left of the van.

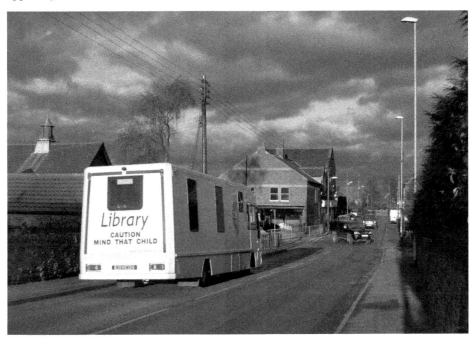

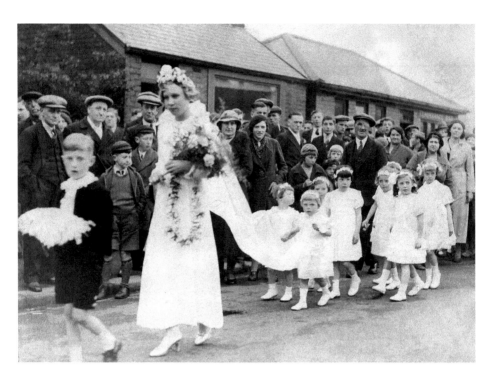

Celebrations – but Alcohol-Free

Miners have often had a reputation for drinking – but of course plenty of liquid was needed after a long shift breathing in coal-dust. It did not have to be alcoholic, though, and there was a temperance bar used by the Rechabites right opposite the pit and the Pack Horse. It is popularly called 'the Temp', and a house with general store has recently been added to it. The picture above shows the May Queen in procession outside the Temp in 1935. The May Queen was Nancy Nicholson.

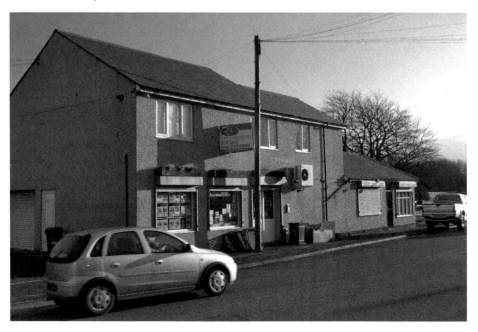

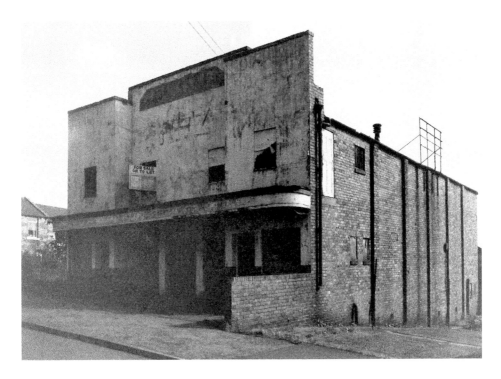

Popular Nights Out

As well as the Saturday night dance at the 'Tute' (The Miners' Institute, now the Community Centre), Greensiders had their own cinema, the Ritz, which opened in 1939. It burnt down in 1942, and at least one family in nearby Charlie Street took refuge from burning debris in their air-raid shelter. It was rebuilt, but finally closed in 1961, becoming a Bingo Hall for a while before it was demolished in 1979. The site (Orchard Court at the bottom of Rockwood Hill) is now occupied by old people's homes.

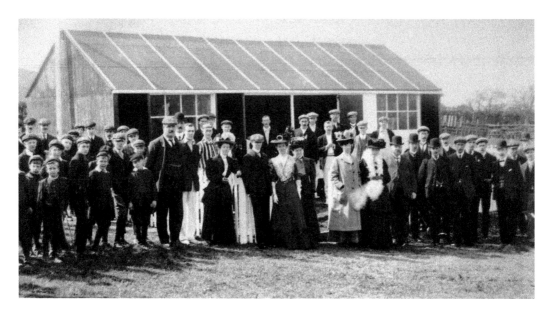

This Sporting Life

Cultivating allotments, pigeon-racing, bird-showing, cycling and football were always popular activities, but Greenside was particularly famous for its Cricket Club. It started life some time before 1891 on Ryton Willows, later playing on a rather sloping ground, where the present bowling green stands, from 1907, before moving to near Greenside Pit, then finally back to Low Greenside in 1923. The picture above is thought to be the opening of the pavilion at the bowling green site.

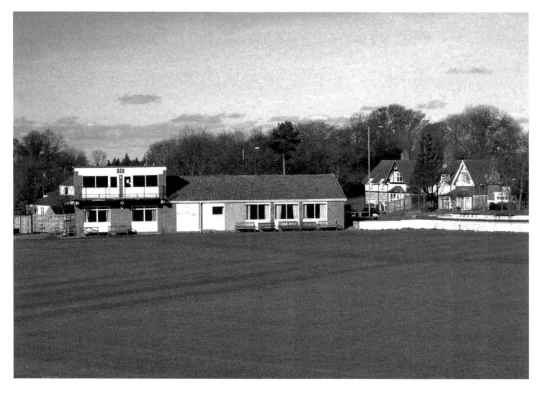

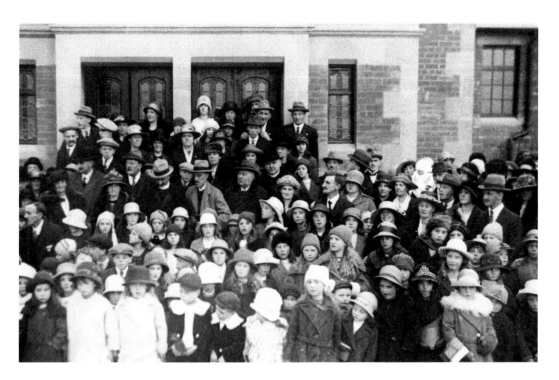

Little John

The parish church and the Methodist chapels were always packed on Sundays. It was St John the Evangelist for whom the parish church is named, but it was a latter-day church leader, John Maughan ('Little John'), who is remembered as a popular steward, Sunday-school teacher and tireless worker for the Wesleyan chapel at the Folly end of the village in Dyke Heads Lane. He can be seen far left centre of the picture above. The chapel opened in 1923 and closed in 1970.

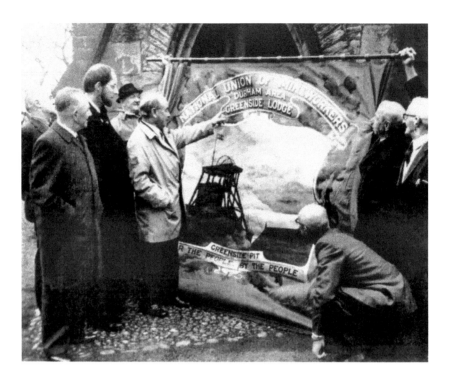

The Miners

During times of peak production Greenside Pit had over 1000 workers. The pit banner came to symbolise the village, and is still paraded once a year to the Miners' Gala in Durham. The banner below is a replica of the old one with one important difference: the back shows not the miners' retirement home in Chester-le-Street, but Greenside School. Those present at its dedication in Durham Cathedral in 2007 will always remember parading the length of the nave at the end of the service and being clapped by the packed congregation and clergy, including the Bishop.

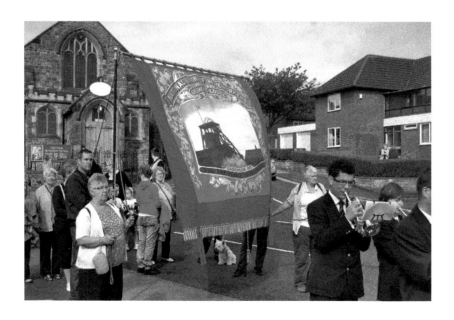

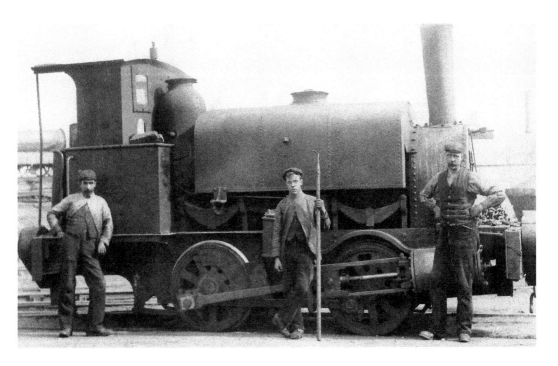

The End of the Line

With the closure of the pit in 1966 came the end of over 300 years of mining and transport history. This locomotive carried coal from the sidings at Greenside just behind the present Millennium Green to Stargate. William Rochester Greener stands on the left. In time for the Millennium, children from Greenside School helped in establishing a walkway along the rail-track (the 'Dilly Line') and turning the land where the Engine Pond once was into a recreation field. The iconic sculpture on the Millennium Green by William Pym commemorates the lead trade.

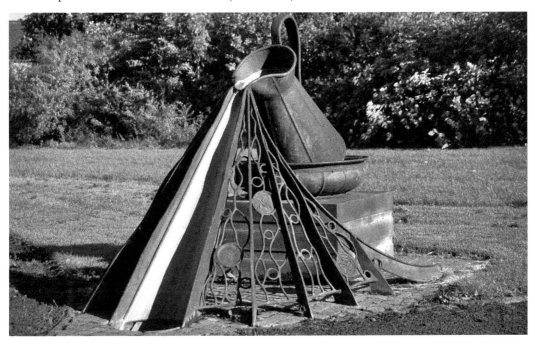

Memories

Our tour through Greenside began in the Memorial Garden where the war dead of two world wars are commemorated. The Cameron Memorial Shelter above has since been demolished. It was a reminder of miners who died in the pit, one of whom was George Cameron, a local Councillor and from 1925 to 1950 secretary of the Management Committee of the Miners' Welfare Hall and Institute. The pit tub we see below is a new addition to the Memorial Garden. Brought to Greenside by the 'Banner Tales Group', it was unveiled on 30 March 2012 and will bring back memories of the history of coal, which for so long dominated this district.

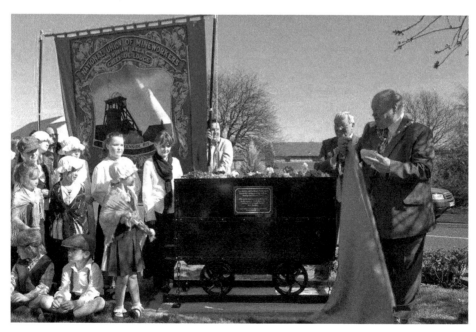